TURNER AT THE TATE

Turner at the Tate

Ninety-two oil paintings by J. M. W. Turner in the Tate Gallery,
reproduced in colour, and with an introduction by

MARTIN BUTLIN

The Tate Gallery

ISBN 0 905005 66 X
Published by order of the Trustees 1980
Copyright © 1980 The Tate Gallery
Designed by Sue Fowler
Published by the Tate Gallery Publications Department,
Millbank, London SW IP 4RG
Printed in Great Britain by Westerham Press, Westerham, Kent

Turner and colour

The figures given in the margin correspond to the plate numbers.

In his use of colour, as in his work as a whole, Turner was one of the most revolutionary artists this country has ever known. His development is all the more extraordinary in that the origins of his art were so traditional and un-revolutionary. The stylistic development between his early and his late paintings is unmatched, as is the range within his work at any one time.

Turner's academic origins are both his strength and, for some critics at any rate, his weakness. Although he had as keen an eye for natural observation as anyone, his finished pictures, those designed for the public to see, always had a non-naturalistic, conceptual basis. His choice of subjects for the oil paintings he exhibited at the Royal Academy reflects the academic tenet that 'high art' necessitated a serious subject, derived from history, classical literature or the Scriptures, and treated in a suitable manner based on the style of the relevant Old Masters. Even Turner's very last exhibits, in 1850, were of four subjects from the story of Dido and Æneas at Troy. He did indeed exhibit non-historical subjects such as ships and storms, avalanches, scenes on the Thames and views of country houses, but many of these, particularly in the first two categories, were raised to the status of the historical subject as a result of the forcefulness of his treatment. Even in his more straightforward landscapes he supported his topographical description of the particular place with a depiction of the occupational or seasonal activities peculiar to it. The results of his study of nature were used in achieving masterpieces not just of observation but of a deliberate didacticism, giving his finished pictures a strength and an authority that they would otherwise have lacked.

Similarly with Turner's use of colour: the lessons of other artists and the colour theories of Goethe and other writers were reinforced by, but at the same time strengthened the results of, his own observations. Turner was 'the father of Impressionism' only in the most limited sense. Whereas the theories of the Impressionists derived from their observations and were intended to bring their pictures closer to the actual processes of sight, Turner's aims were always expressive, not naturalistic.

The first oil painting exhibited by Turner at the Royal Academy, in 1796, was 'Fishermen at Sea', a scene off the Needles. This is typical of Turner's whole achievement in the way it looks both forward and back. The lozenge-shaped framework of the composition looks forward to many of Turner's later works and the two contrasted sources of light, one warm, one cold, already reveal Turner's interest not just in light and colour as such but in their more subtle aspects. Nevertheless, this same interest in contrasted light sources is a device that Turner had learnt from a whole school of painters of night scenes in the eighteenth century, including Joseph Vernet, Joseph Wright of Derby and P.J. de Loutherbourg. In particular the rather leathery finish echoes Wright, whose 'Moonlight with a Lighthouse, Coast of Tuscany' (now in the Tate Gallery) had been exhibited at the Royal Academy in 1789, the year in which Turner first went to the Academy as a student.

1

Turner's interest in special effects of light, coupled with those of climate and weather, was again demonstrated in the rainbow that is the main feature of one of his exhibits two years later, 1798, 'Buttermere Lake, with Part of Cromackwater, Cumberland, a Shower'. Here, however, his treatment is much more painterly and reflects the style of Richard Wilson, the British landscape painter whom Turner admired above all others. As well as in the actual application of paint, Wilson's technique is reflected in the little flecks of bright colour, blues, reds and yellows, that are found in many of Turner's pictures of 1798–1800.

3

At the same time, however, Turner was using the example of earlier artists, together with his own imagination, to express the completely different light and colour of Italy, as in 'Æneas and the Sibyl, Lake Avernus'. This Claudian view was based on an on-the-spot drawing by Turner's patron, Sir Richard Colt Hoare, with a classical subject introduced to raise the landscape to the status of history-painting. Compared with Turner's many later pictures in the same vein, the large panoramic landscapes such as 'The Bay of Baiae', 'Childe Harold's Pilgrimage' and 'Apollo and Daphne', his success here is very limited, but the extent of his ambitions is already clear.

4

33,58,59

Indeed, it was in furthering these ambitions that Turner consolidated his early successes at the Royal Academy. In 1799, he was elected an Associate of the Royal Academy and in 1802 a full member, by which time he had already shown the first of a series of large pictures of Biblical subjects, such as the plagues of Egypt, and marines. Later examples, from the first

6

8

7

17

16

decade of the nineteenth century, are 'Calais Pier', 1803 (in the National Gallery), and 'The Shipwreck', which Turner exhibited in his own gallery in 1805 when, as the result of art politics, he preferred to withhold his works from the Royal Academy; another example was 'The Goddess of Discord Choosing the Apple of Contention in the Garden of the Hesperides', shown at the British Institution in 1806. These depend greatly on the example of the Old Masters. 'The Shipwreck' is one of the works in which Turner began to transform the tradition of marine painting established in England in the later seventeenth century by the Van de Veldes, father and son. The general colour scheme and the small Teniers-like figures are close to Dutch examples, but the vigour of Turner's application of paint and the much more dynamic construction of the picture, which is based, like the early 'Fishermen at Sea', on a lozenge, are Turner's own contribution. 'The Garden of the Hesperides' also looks back to an Old Master, this time Titian, in its general composition, figure types and colouring. Also in this same series of grand exhibition pictures is 'The Battle of Trafalgar, as seen from the Mizen Starboard Shrouds of the Victory', first shown at Turner's gallery in 1806 and again, after some reworking, at the British Institution in 1808. This is much more daring in its composition and in its application of the tradition of history-painting to a modern subject but even here there are precedents in the work of such artists as John Singleton Copley.

At the same time as Turner was displaying his powers in large, dramatic canvases, he was also pursuing the more intimate depiction of the British landscape under varying conditions of light and atmosphere. In a series of scenes on the Thames estuary Turner again developed the Van de Velde tradition though now in the opposite sense to that followed in 'The Shipwreck'. 'Fishing upon the Blythe-Sand, Tide setting in', exhibited in Turner's gallery in 1809, is a particularly delicately observed example, close to a group of oil sketches on canvas which may even, contrary to Turner's usual practice, have been done on the spot; these include the closely related 'Shipping at the Mouth of the Thames'. The sketch, though fresher still than the exhibited picture, is nevertheless already consciously pictorial in its carefully controlled diagonal stresses of sails and beams of sunlight. The contrast of light-toned sails on the left and dark on the right seems to be the result of a deliberate decision made for compositional reasons, not a matter of chance observation.

Others from this group of sketches, as well as a number of smaller oil sketches on mahogany veneer, show scenes further up the Thames and on its tributaries. The two groups show the different colouristic effect of the two kinds of ground: the canvases have a cool white gesso ground while in the case of those on mahogany Turner either painted directly onto the wood itself or covered it with such a thin ground that the warmth of the wood shows through. *11–14*
18–21, 28

The large Thames sketches, though features from them were developed in other pictures finished for exhibition, may also in some cases have been works on the way to completion themselves. 'Goring Mill and Church' for example exactly parallels Turner's early unfinished watercolours in that the centre of the picture is completely finished in colour while the extremities are left as bare ground. Even the finished pictures such as 'London' and 'Ploughing up Turnips, near Slough', both exhibited in Turner's gallery in 1809, and 'Dorchester Mead, Oxfordshire', exhibited in Turner's gallery the following year, show the same subtle colour and feeling for atmosphere, refined upon from the sketches rather than radically altered. The white grounds common to all these pictures were however radical enough to arouse criticism from Sir George Beaumont and other connoisseurs: Turner and his followers were pronounced 'white painters', used as a term of abuse in a way difficult to understand today. *14*

15
22
23

These paintings of scenes on the Thames, like Turner's other domestic landscapes, were on the whole shown at his own gallery, though when he painted country houses, the seats of his patrons, they were shown at the Royal Academy as in the case of the well-known views of Petworth, 1810 (still at Petworth House) and Somerhill, 1811 (now in the National Gallery of Scotland). However, 'Frosty Morning' (probably a view in Yorkshire), the distillation of Turner's most direct observation of the English landscape under various climatic conditions with little else in the way of subject, was shown at the Royal Academy in 1813. Seeing it there, even Constable's great patron Archdeacon Fisher had to acknowledge Turner's superiority in the genre at which he most approached his fellow artist: 'but then you need not repine at this decision of mine,' wrote Fisher to Constable; 'you are a great man like Buonaparte, and are only beaten by a frost.' Indeed, the whole effect of this winter landscape just touched by frost is unsurpassed in English painting. *26*

Meanwhile Turner continued to show more ambitious works at the Royal Academy, for

instance 'The Fall of an Avalanche in the Grisons' in 1810 and 'Snow Storm: Hannibal and his Army crossing the Alps' in 1812. The title of the latter reveals Turner's true interest, in the natural phenomenon rather than the historical event, and indeed the first inspiration for the picture was said to have been a storm seen in Yorkshire two years earlier. Turner here uses and exalts the natural phenomenon to express the drama of the historical event; in many of his later works the drama of nature was to take over altogether. The dramatic force of both these pictures is largely conveyed by their compositions, though in the case of 'The Fall of an Avalanche' the boldness with which Turner has applied the white paint to convey the force of the falling snow also contributes to the effect. In 'Avalanche' the sky is leaden, but in 'Hannibal', equally naturalistically perhaps but in a sense more boldly, Turner shows a patch of brilliant, clear blue sky in the distance through a rent in the clouds.

After 'Hannibal' Turner's Academy pieces, though still often large in size, became calmer in mood. Claude and Cuyp, rather than the more dramatic of the Old Masters, became the predominant influence, though tempered more than ever by Turner's own observations. Even the highly Claudian 'Decline of the Carthaginian Empire', shown in 1817 and companion to 'Dido building Carthage' of two years earlier (now in the National Gallery), shows a richness of incidental detail and a subtlety of lighting that result from Turner's detailed study of nature. A more radical synthesis is seen in 'Crossing the Brook', exhibited in 1815; in this picture a scene in South Devon is transformed into a Claudian landscape partly by the careful placing of such details as the framing trees and the bridge in the middle distance but even more by the suffusing warmth of the light and colour.

The picture's light tonality again enraged Sir George Beaumont, who described the picture as 'all of a *peagreen* insipidity', but today it is the picture's Old Master quality that is most apparent, as indeed it is with 'England: Richmond Hill, on the Prince Regent's Birthday' exhibited in 1819 and one of Turner's two biggest ever exhibits. This is a modern history-piece with an almost playful use of incidental detail, as in the lively dog, the drum and the billowing flag. The subtlety of the colour observation, albeit within the generally traditional treatment of light and shade that still rules Turner's works at this time, is amazing, for instance in the scarlet coats of the Royal Heralds as they are transmuted in the half-shadows. A sea-piece of the same year, 'Entrance of the Meuse: Orange-Merchant on

24, 25

27

29

31

30

the Bar, going to Pieces', also reflects the taming of what could have been a highly dramatic subject. Turner is here more interested in the incredibly varied types of clouds, and in the punning use of the strongly coloured oranges that enliven the foreground, than in the fact that he is painting what is in one sense a sequel to 'The Shipwreck'. *6*

When Turner finally went to Italy for the first time in 1819 the immediate effect on his oil painting was if anything inhibitory, though his private watercolours of Venice tell a different story. His output, already somewhat reduced after about 1812, slackened still more; in 1821 and 1824 he exhibited nothing at all. The three big Italian scenes, 'Rome, from the Vatican', *32* 'The Bay of Baiae' and 'Forum Romanum', exhibited in 1820, 1823 and 1826 respectively, *33, 35* are a demonstration of his new repertoire and his new ambitions, but do not show the radical change in his colouring that one might expect. The transformation in Turner's colour occurred rather in his unexhibited works, the Cowes and Petworth sketches of 1827 and about 1828 respectively.

The Cowes sketches fall into two categories. Some, such as 'Shipping off East Cowes *36* Headland', show a new subtlety and delicacy, with delicate glazes of colour and stronger accents in the sky to enliven the near monochrome of the general effect; this was a device much used in later sea-pieces. There is a bold use of the brush handle (or perhaps Turner's own thumb-nail) to add texture to the small areas of thick impasto reserved for the figures in the nearest boat. This boldness is the dominant characteristic of the other group of sketches *37* in the group, those showing the regatta beating to windward, which were used for one of the two finished pictures of the regatta exhibited at the Royal Academy the following year, 1828. Amazingly, the Cowes sketches (nine in all) were painted on two undivided canvases that were only cut up into separate pictures early in the twentieth century. The two rolls of canvas seem to have been painted on alternately rather than according to subject, presumably for ease of handling; some at least of the sketches were probably painted on board a ship anchored off-shore and Turner would have switched from one roll to the other to get rapid impressions of the regatta as it passed by.

The use of the brush handle in wet paint is also a feature of 'George IV at the Provost's *34* Banquet, Edinburgh'. This was painted on a special visit made in connection with a scheme to depict various episodes of the Royal visit to Edinburgh in 1822.

The Petworth sketches, painted for the third Earl of Egremont in about 1828, show a new subtlety even beyond that of the more ethereal of the Cowes sketches. Whereas six of the nine Cowes sketches were used for finished pictures exhibited the following year, the so-called Petworth sketches seem actually to have been intended for display, set into the Grinling Gibbons panelling of the dining-room at Petworth; however, they were soon replaced by four more finished versions, perhaps because Lord Egremont, a great patron of Turner in his earlier years, did not appreciate his new freedom of handling. An extra subject among the sketches, 'A Ship Aground', was not used at Petworth but was later freely adapted in two pictures exhibited in 1831.

Particularly remarkable as an example of Turner's combination of delicacy and boldness is the treatment of the sun in that picture and in 'Chichester Canal'. In 'Ship Aground' it is suggested by two streaks of orange painted over the blue-grey sky, while in 'Chichester Canal' the optical effect of the sun setting behind hills and actually appearing to cut into them is shown by superimposing a rough indication of the sun in yellow impasto over the blue of the distant hills. In these sketches the convention of indicating shadows by dark browns and greys seems finally to have been abandoned. When these colours do appear they are used colouristically, as they actually appear, rather than conceptually. But unlike the Impressionists Turner's use of colour was not an end in itself but subservient to the total effect.

Indeed, in one group of works associated with Petworth, the heavily worked oils of interior scenes, colour is used emotively and even sometimes in an almost abstract way. 'Music Party, Petworth' and 'Two Women with a Letter' (parallels in oils to the studies of figures in interiors painted at Petworth in gouache on blue paper) show Turner's use of colour at its boldest in combination with a very rich handling of paint; the paint is thickly applied and worked with a palette knife, scratched and gouged, partly to suggest the texture of wall-hangings and leather or the effect of figures in a capriciously lit room, but partly to add to the frisson of the scene depicted. In the famous 'Interior at Petworth' the emotional effect is such as to have suggested that the picture was Turner's farewell to Petworth following the death of Lord Egremont in 1837; suggestions of a catafalque are accompanied by a frenzy of leaping dogs and dissolving forms. Areas of strong colour are used almost arbitrarily in the interests of the effect as a whole, particularly the green that floods in from the right. Cracks in the

38–41

41

38

66

67

65

heavily worked surface reveal a bright scarlet undercoat which cannot be explained in any naturalistic way.

The richness of effect in these interiors is also found in some of Turner's exhibited figure subjects of roughly the same time, such as 'Pilate washing his Hands', exhibited in 1830. *64* Here his continuing interest in significant subject matter and its most appropriate expression led him to re-interpret Rembrandt's crowded figure compositions in dim interiors, but whereas Rembrandt painted primarily in dark tones, enlivened by strong effects of light and shade, Turner expressed the same flickering excitement in full colour. Again one can see the almost abstract use of strong colours in the red of the Virgin's robe and the rich greens and light blues of the nearby fabrics.

This use of stronger colours may have resulted in part from Turner's second and, so far as oil paintings were concerned, far more productive visit to Italy in the winter of 1828–9. A number of bold oil sketches were almost certainly done on this trip, again on two rolls of *42, 44–5, 47–8* canvas, sixteen sketches in all. 'Lake Nemi' and 'Fishing Boat in a Mist' show great splashes *45, 44* of bright blue and white impasto. The waterfalls and other features in the foreground of 'Tivoli, the Cascatelle' are intimated by flashes of white. The mood ranges from the bright *48* and sun-soaked 'Lake Nemi' to the stormy and oppressive 'Archway with Trees by the Sea', *47* and is always conveyed primarily by colour.

Turner also finished a number of oil paintings and exhibited them in Rome. These included 'Orvieto', 'Vision of Medea' and 'Regulus', though the first and last were reworked *52, 51, 53* before being exhibited again back in London in 1830 and 1837 respectively. 'Medea' is particularly close to the sketches in its bold handling and the leaving bare or nearly bare for textural effect of the coarse Italian canvas. In 'Regulus' the very intensity of the light adds to the impact of the subject, for Regulus, a Roman hostage in the hands of the Carthaginians, was punished by having his eyelids cut off and being bound facing the sun, which eventually blinded him. Other large canvases begun in Italy but left unfinished include the 'Reclining *50* Venus', another example of Turner's renewed interest in showing figures on a relatively large scale, in this case directly inspired by Titian's famous 'Venus of Urbino' which Turner would have seen in Florence on the way to Rome.

Turner's finished Roman pictures, sent by sea, failed to reach London in time for the 1829

exhibition, but Turner developed one of his Roman sketches in the famous 'Ulysses deriding Polyphemus', now in the National Gallery. In this a new strength and brightness of colour was immediately apparent. The effect of Turner's second visit to Italy can also be seen by comparing 'Childe Harold's Pilgrimage – Italy', exhibited in 1832, with 'Bay of Baiae' of nine years earlier. The colour key is higher, though with less strong contrasts, and the treatment more diffuse, this being matched by a composition based much more on curvilinear forces than on the traditional system of diagonal recession into depth. Atmosphere also plays a much greater part. In 'Caligula's Palace and Bridge', exhibited in 1831, and the later 'Ancient Rome; Agrippina landing with the Ashes of Germanicus. The Triumphal Bridge and Palace of the Caesars restored', shown in 1839, the very buildings dissolve in the shimmering light.

In 1833, Turner exhibited his first two oils of Venice, despite the fact that he had not actually been there since 1819. One is lost; the other, 'Bridge of Sighs, Ducal Palace and Custom-House, Venice: Canaletti painting', shows the strong, bright colours of other works of this period. Turner's later views of Venice, mainly from the 1840s, are more atmospheric, sharing the delicate translucency of his late Venetian watercolours. The suggestion of architectural detail in, for instance, the background of 'The Sun of Venice going to Sea', exhibited in 1843, is achieved by strokes of red drawn with the point of the brush in a way exactly paralleled in many of the late watercolours. Typically for late works such as these it is often the glowing sunset sky that is the most heavily painted part of the picture, as, for instance, in 'St Benedetto, looking towards Fusina', also shown in 1843.

Also from the 1830s and 1840s, though strongly contrasted in mood, is the series of oil paintings of stormy seas, some showing the strong colouring of the Italian views, others however being nearly monochromatic though these are often enlivened, as in 'Rough Sea with Wreckage', with tiny areas of undiluted red. The near monochrome of many of this group suggests the wild fury of the sea, while the more colourful examples such as 'Stormy Sea with Dolphins' may depict scenes of fire at sea. In the large picture of that title the actual source of the fire is outside the picture on the right; here in fact we have Turner's last treatment, on the same large scale, of the subject of wrecked seafarers helpless in tiny boats that had obsessed him since 'The Shipwreck' of 1805.

The sea-pieces just mentioned were never exhibited by Turner in his lifetime but by the 1840s the distinction between his exhibited and his unexhibited works was far less apparent than it had been earlier. 'Snow Storm – Steam-Boat off a Harbour's Mouth', exhibited at the Royal Academy in 1842, is hardly more finished than Turner's other pictures of storms at sea. It is perhaps the most developed of the group in its composition, faceted and spiralling to concentrate attention on the beleaguered paddle-boat at the centre of the vortex. A similar composition also dominates the much more strongly coloured painting, not exhibited in Turner's lifetime, of 'Yacht approaching the Coast'. Turner's pictures of the sea and all its moods resulted from first-hand experience; frequent trips to the Continent and along the coast of Britain exposed him to all the rigours of the elements. 'Snow Storm – Steam-Boat off a Harbour's Mouth' was the result of a specific experience: the Royal Academy catalogue included the note, 'The author was in this storm on the night the Ariel left Harwich', and he later told a visitor to his studio that he had been lashed to the mast for four hours and had not expected to survive. Other exhibited pictures of marine subjects included four of whaling ships exhibited in 1845 and 1846. These are distinguished from one another not only by the specific incidents shown but also by each one having its own predominant colouring.

This was something Turner had already done in a series of paired pictures, such as 'Peace – Burial at Sea' and 'War. The Exile and the Rock Limpet' of 1842. The cold, funereal colours of the former, a tribute to his fellow painter Sir David Wilkie, are contrasted to the blood-red sunset dominating the exiled Napoleon, who compares his fate to that of the rock-fast limpet. The following year he exhibited a similar pair with titles that make direct reference to Goethe's treatise on colour: 'Shade and Darkness – the Evening of the Deluge' and 'Light and Colour (Goethe's Theory) – the Morning after the Deluge – Moses writing the Book of Genesis'. Goethe had postulated a colour circle similar to the prismatic scale and had divided this into 'plus' and 'minus' colours. Turner chose his Old Testament subjects to suit. The 'Deluge' was shown in the blues, blue-greens and purples that were seen by Goethe as productive of 'restless, susceptible, anxious impressions', while the 'Morning after' was shown in the reds, yellows and greens associated by Goethe with gaiety, warmth and happiness. However, for Turner, whose philosophy had grown increasingly more pessimistic, even the 'positive' picture was accompanied in the catalogue by verses alluding to the

83

72

89

76
77

84
85

fleetingness of hope. These verses were attributed to the '*Fallacies of Hope, MS*' from which Turner often quoted. This purported to be a complete epic in manuscript but it is almost certain that Turner made up his verses as he went along according to the requirements of the particular picture that he was to exhibit. Despite a keen interest in history, contemporary events and philosophic issues, and despite the continuing legacy from his training at the Royal Academy of a belief that the most significant art must be a medium for important ideas, his inspiration was primarily visual.

68
71, 74

This is demonstrated by a group of unfinished oil paintings that forms one of the chief glories of the Turner Bequest. This group includes such works as 'Norham Castle, Sunrise', 'Sunrise, a Castle on a Bay' and two mountain landscapes. These 'colour beginnings' (to use a term commonly applied to a category of Turner's unfinished watercolours) are quite literally that, thin washes of colour setting out the main forms of a composition later to be developed into a finished picture. There are a sufficient number of eye-witness accounts to show that from 1830 if not earlier Turner would take such unfinished canvases into the Royal Academy and, during the three varnishing days before the exhibition was opened to the public, work them up into finished pictures worthy of public attention. The finished pictures would often have detailed historical subjects, their titles specified in the exhibition catalogue, which means that Turner must already have had a pretty good idea of the final result before he sent in his unfinished canvases (though the final printing of the catalogues was done in a remarkably short space of time). It seems nevertheless that he would work these pictures up from the slightest of colour impressions. 'The Burning of the House of Lords and Commons' was sent in to the British Institution in 1835 in a form described as 'a mere dab of several colours, and "without form and void", like chaos before the Creation', little better than 'a

69
70
78, 79, 81
80, 89, 83
57, 82

bare canvas'. So 'Ancient Rome', for instance, would have been completed when already hanging on the Royal Academy walls over such a sketch as 'Sunrise, with a Boat between Headlands'; the small Venetian pictures of the 1840s would have been finished over such lay-ins as 'Venice with the Salute'; and the Whalers pictures and 'Snow Storm – Steam-Boat off a Harbour's Mouth' over paintings of the type of 'Rough Sea with Wreckage' and 'Rough Sea'. These unfinished canvases may well have stood around Turner's studio for some years, awaiting the needs of the regular annual exhibitions. It is therefore probable that it is at least

partly luck that has resulted in so many remaining untouched in their original freshness. Our delight in these pictures is a justifiable expression of the change in taste over the past hundred years or so but it is certain that Turner would not have regarded them as finished works of art.

Turner continued to exhibit at the Royal Academy up to 1850, the year before he died. This year saw no fewer than four canvases on the single theme of Æneas at Carthage, a theme chosen for its historic associations and because Turner saw in the fall of ancient empires such as that of Carthage a lesson to be learnt in his own day. It has to be admitted, however, that these works reveal a tired man in their congested paint and rather hot, foxy colours. Ruskin indeed saw Turner's decline as starting as early as 1845, and it is clear that Turner found it increasingly difficult to prepare works for exhibition in his last years. After showing six works at the Royal Academy and one at the British Institution in 1846 he showed one work only at the Academy in 1847 and that, 'The Hero of a Hundred Fights', was an early work of about 1800–10 over-painted with the scene of the casting of Wyatt's equestrian statue of the Duke of Wellington in 1845; the rich glow of Turner's addition contrasts markedly with the dark near monochrome of Turner's early style. The following year, 1848, he exhibited nothing at all and in 1849 only two works, again earlier paintings and in one case ('The Wreck Buoy' at Liverpool) again completely reworked.

Indeed, one critic, reviewing 'Whalers' at the Royal Academy in 1845, reported a rumour that this was to be the last year in which Turner was to exhibit. Ruskin dated Turner's decline specifically to 'within a limit of three to four months, towards the close of the year 1845'. In 1846 Turner exhibited one picture in particular that seems to have represented a deliberate farewell, 'The Angel standing in the Sun', a scene from the Book of Revelation which seems also to represent the summing up of his achievement as a painter of light, light seen as the sum of colour. It is with this apocalyptic summation, rather than the later works of his decline, that one should, perhaps, conclude this brief summary of Turner's career.

91

90

92

For further reading

Turner's oil paintings are illustrated and catalogued in detail in
Martin Butlin and Evelyn Joll, *The Paintings of J.M.W. Turner*, 2 vols., 1977.

John Ruskin, *Modern Painters*, 5 vols. 1843–60, reprinted in *Library Edition*, edited by E.T. Cook and Alexander Wedderburn, vols. III–VII, 1903–5.

John Burnet, *Turner and his Works*, with a 'Memoir' by Peter Cunningham, 1852; 2nd ed. 1859.

John Ruskin, *Notes on the Turner Gallery at Marlborough House 1856*, 1857; *Library Edn*, vol. XIII, 1904.

Walter Thornbury, *The Life of J.M.W. Turner R.A.*, 2 vols., 1862; 2nd ed. in one volume, 1876.

W.G. Rawlinson, *The Engraved Work of J.M.W. Turner, R.A.*, 2 vols., 1908 and 1913.

A.J. Finberg, *Complete Inventory of the Drawings of the Turner Bequest*, 2 vols., 1909.

A.J. Finberg, *Turner's Sketches and Drawings*, 1910; paperback reissue with an introduction by Lawrence Gowing, 1968.

A.J. Finberg, *The History of Turner's Liber Studiorum with a New Catalogue Raisonné*, 1924

A.J. Finberg, *In Venice with Turner*, 1930.

A.J. Finberg, *The Life of J.M.W. Turner, R.A.*, 1939; 2nd edition 1961.

Kenneth Clark, 'The Northern Lights', in *Landscape into Art*, 1949; new edition 1976.

Martin Butlin, *Turner Watercolours*, 1962 and subsequent editions.

Adrian Stokes, 'The Art of Turner (1775–1851)', in *Painting and the Inner World*, 1963.

Michael Kitson, *Turner*, 1964.

John Rothenstein and Martin Butlin, *Turner*, 1964.

Lawrence Gowing, *Turner: Imagination and Reality*, 1966.

Jack Lindsay, *J.M.W. Turner, His Life and Work*, 1966.

Luke Herrmann, *Ruskin and Turner*, 1968.

John Gage, *Colour in Turner*, 1969.

Graham Reynolds, *Turner*, 1969.

Gerald Wilkinson, *Turner's Early Sketchbooks*, 1972.

Gerald Wilkinson, *The Sketches of Turner R.A., 1802–20*, 1974.

Martin Butlin, Andrew Wilton and John Gage, *Turner, 1775–1851*, Royal Academy exh. cat., 1974–5.

Luke Herrmann, *Turner*, 1975.

Mordechai Omer, exh. cat., *Turner and the Poets*, Marble Hill, Norwich and Wolverhampton, 1975.

Gerald Wilkinson, *Turner's Colour Sketches, 1820–34*, 1975.

Andrew Wilton, exhibition catalogue, *Turner in the British Museum, Drawings and Watercolours*, British Museum, 1975–6.

John Russell and Andrew Wilton, *Turner in Switzerland*, 1976.

Andrew Wilton, *The Life and Work of J.M.W. Turner*, 1979.

A note on the Turner Bequest

Although Turner's wills and their various codicils have been the subject of much controversy the basic facts are simple and incontrovertible. Turner's intentions changed radically between, on the one hand, his first two wills of 1829 and 1831 and a codicil of 1832, and, on the other, three codicils of 1848 and 1849. At first he planned that a separate gallery for all 'my pictures' that remained in his possession should be built as part of 'Turner's Gift', a charitable institution to be set up at Twickenham for the support of 'Poor and Decayed Male Artists'. However, in the late 1840s Turner changed his mind: all his 'finished Pictures' were to go to the National Gallery on condition that 'a room or rooms', to be called 'Turner's Gallery', should be added to the existing Gallery. The reasons for this change are not documented but it is likely that Turner was influenced by Robert Vernon's gift to the National Gallery in 1847 of 155 pictures by British artists ranging from Richard Wilson to Vernon's contemporaries, including four oils by Turner himself. This transformed the National Gallery collection from one primarily devoted to foreign old masters (in 1847 the collection consisted of about 215 works of which only 40 were by British artists) to one in which works by British artists made up over half the total. Turner had always painted very much with an eye both on his predecessors and on his contemporaries and had indeed from the beginning specifically bequeathed two of his landscapes, 'Sun rising through Vapour' and 'Dido building Carthage', to the National Gallery to hang next to two paintings by Claude. Now the rest of his paintings could be seen in the context of the British School, beginning with Wilson whom Turner regarded as the father of British landscape painting.

Turner's relations (he had no legitimate children) contested the terms of his will and finally, to avoid the immense delays in the Court of Chancery later so evocatively recounted by Charles Dickens in *Bleak House*, a settlement was reached whereby the relations got the money that would otherwise have gone to the charitable foundation for poor artists while the National Gallery received not only the 'finished Pictures' but all the oil paintings, watercolours, drawings and sketchbooks remaining in Turner's possession. Just what Turner had meant by 'finished Pictures' is unclear but it seems likely that the National Gallery followed what would have been his general line of demarcation in allocating inventory numbers only to those oil paintings exhibited by Turner in his own lifetime, together with about fifteen other works of similar character and finish; the rest, over half, were not given numbers until the twentieth century (these can be distinguished from the earlier numbers as they consist of four rather than three digits). Some of the watercolours and drawings were given numbers when they were placed on exhibition later in the nineteenth century but again no full inventory was made until the twentieth century. At present nine of the most important oil paintings are on exhibition at the National Gallery, the remainder being housed at the Tate Gallery, opened in 1897 as an offshoot of the National Gallery to house the national collection of British painting though now, since 1955, an independent body; in 1910 a series of galleries built at the expense of Sir Joseph Duveen was opened to house the Turner Bequest. The watercolours, drawings and sketchbooks, which remain the property of the National Gallery, are housed in the Department of Prints and Drawings at the British Museum; a changing selection is normally on view at the Tate. However, as the result of a splendid gift from the Clore Foundation plans are now in hand for the construction of a new gallery to be devoted entirely to Turner, linked to the Tate Gallery but distinct from it, and to be known as the Clore Gallery. All of the oil paintings will be available without formality, either in the main galleries or in a reserve, and these will be accompanied by changing displays of watercolours and drawings.

List of plates

Measurements are given in inches, followed by centimetres in brackets; height precedes width

1 *Fishermen at Sea*, exh.1796. Canvas, $36 \times 48\frac{1}{8}$ (91.5×122.4). Acq.no.T.1585.

2 *Morning amongst the Coniston Fells, Cumberland*, exh. 1798. Canvas, $48\frac{3}{8} \times 35\frac{1}{16}$ (123×89.7). Acq.no.461.

3 *Buttermere Lake, with Part of Cromackwater, Cumberland, a Shower*, exh.1798. Canvas, $36\frac{1}{2} \times 48$ (91.5×122). Acq.no.460.

4 *Æneas and the Sibyl, Lake Avernus*, c.1798. Canvas, $30\frac{1}{8} \times 38\frac{3}{4}$ (76.5×98.5). Acq.no.463.

5 *View on Clapham Common*, c.1800–5. Mahogany, $12\frac{5}{8} \times 17\frac{7}{16}$ (32×44.5). Acq.no.468.

6 *The Shipwreck*, exh.1805. Canvas, $67\frac{1}{8} \times 95\frac{1}{8}$ (170.5×241.5). Acq.no.476.

7 *The Battle of Trafalgar, as seen from the Mizen Starboard Shrouds of the Victory*, exh.1806; reworked and exh.1808. Canvas, $67\frac{1}{4} \times 94$ (171×239). Acq.no.480.

8 *The Goddess of Discord choosing the Apple of Contention in the Garden of the Hesperides*, exh.1806. Canvas, $61\frac{1}{8} \times 86$ (155×218.5). Acq.no.477.

9 *Spithead: Boat's Crew recovering an Anchor*, exh. 1808. Canvas, $67\frac{1}{2} \times 92\frac{5}{8}$ (171.5×235). Acq.no.481.

10 *A Country Blacksmith disputing upon the Price of Iron*, exh.1807. Pine, $21\frac{5}{8} \times 30\frac{5}{8}$ (55×78). Acq.no.478.

11 *Barge on the River*, c.1806–7. Canvas, $33\frac{1}{2} \times 45\frac{3}{4}$ (85×116). Acq.no.2707.

12 *Washing Sheep*, c.1806–7. Canvas, $33\frac{1}{4} \times 45\frac{7}{8}$ (84.5×116.5). Acq.no.2699.

13 *Willows beside a Stream*, c.1806–7. Canvas, $33\frac{7}{8} \times 45\frac{3}{4}$ (86×116.5). Acq.no.2706.

14 *Goring Mill and Church*, c.1806–7. Canvas, $33\frac{3}{4} \times 45\frac{3}{4}$ (85.5×116). Acq.no.2704.

15 *London*, exh.1809. Canvas, $35\frac{1}{2} \times 47\frac{1}{4}$ (90×120). Acq.no.483.

16 *Shipping at the Mouth of the Thames*, c.1806–7. Canvas, $33\frac{3}{4} \times 46$ (86×117). Acq.no.2702.

17 *Fishing upon the Blythe-Sand, Tide setting in*, exh.1809. Canvas, 35×47 (89×119.5). Acq.no.496.

18 *Windsor Castle from Salt Hill*, c.1807. Mahogany veneer, $10\frac{7}{8} \times 29$ (27×73.5). Acq.no.2312.

19 *The Thames near Walton Bridges*, c.1807. Mahogany veneer, $14\frac{5}{8} \times 29$ (37×73.5). Acq.no.2680.

20 *Tree Tops and Sky, Guildford Castle (?), Evening*, c.1807. Mahogany veneer, $10\frac{7}{8} \times 29$ (27.5×73.5). Acq.no.2309.

21 *Godalming from the South*, c.1807. Mahogany veneer, $8 \times 13\frac{3}{4}$ (20×35). Acq.no.2304.

22 *Ploughing up Turnips, near Slough*, exh.1809. Canvas, $40\frac{1}{8} \times 51\frac{1}{4}$ (102×130). Acq.no.486.

23 *Dorchester Mead, Oxfordshire*, exh.1810. Canvas, $40 \times 51\frac{1}{4}$ (101.5×130). Acq.no.485

24 *The Fall of an Avalanche in the Grisons*, exh.1810. Canvas, $35\frac{1}{2} \times 47\frac{1}{4}$ (90×120). Acq.no.489.

25 *Snow Storm: Hannibal and his Army crossing the Alps*, exh.1812. Canvas, $57\frac{1}{2} \times 93\frac{1}{2}$ (146×237.5). Acq.no.490.

26 *Frosty Morning*, exh.1813. Canvas, $44\frac{3}{4} \times 68\frac{3}{4}$ (113.5×174.5). Acq.no.492.

27 *The Decline of the Carthaginian Empire*, exh.1817. Canvas, 67×94 (170×238.5). Acq.no.499.

28 *Sunset on the River*, c.1807. Mahogany veneer, $6\frac{1}{16} \times 7\frac{5}{16}$ (15.5×18.5). Acq.no.2311.

29 *Crossing the Brook*, exh.1815. Canvas, 76×65 (193×165). Acq.no.497.

30 *Entrance of the Meuse: Orange-Merchant on the Bar, going to Pieces*, exh.1819. Canvas, 69×97 (175.5×246.5). Acq.no.501.

31 *England: Richmond Hill, on the Prince Regent's Birthday*, exh.1819. Canvas, $70\frac{7}{8} \times 131\frac{3}{4}$ (180×334.5). Acq.no.502.

32 *Rome, from the Vatican. Raffaelle, accompanied by La Fornarina, preparing his Pictures for the Decoration of the Loggia*, exh.1820. Canvas, $69\frac{3}{4} \times 132$ (177×335.5). Acq.no.503.

33 *The Bay of Baiae, with Apollo and the Sibyl*, exh.1823. Canvas, $57\frac{1}{4} \times 94$ (145.5×239). Acq.no.505.

34 *George IV at the Provost's Banquet in the Parliament House, Edinburgh*, c.1822. Mahogany, $27 \times 36\frac{1}{8}$ (68.5×91.8). Acq.no.2858.

35 *Forum Romanum, for Mr Soane's Museum*, exh.1826. Canvas, $57\frac{3}{8} \times 93$ (145.5×237.5). Acq.no.504.

36 *Shipping off East Cowes Headland*, 1827. Canvas, $18\frac{1}{8} \times 23\frac{3}{4}$ (46×60). Acq.no.1999.

37 *Sketch for 'East Cowes Castle, the Regatta beating to Windward' no. 2*, 1827. Canvas, $17\frac{3}{4} \times 23\frac{7}{8}$ (45×60.5). Acq.no.1994.

38 *Chichester Canal*, c.1828. Canvas, $25\frac{3}{4} \times 53$ (65.5×134.5). Acq.no.560.

39 *Petworth Park: Tillington Church in the Distance*, c.1828. Canvas, $25\frac{3}{8} \times 57\frac{3}{8}$ (64.5×145.5). Acq.no.559.

40 *The Chain Pier, Brighton*, c.1828. Canvas, $28 \times 53\frac{3}{4}$ (71×136.5). Acq.no.2064.

41 *A Ship Aground*, c.1828. Canvas, $27\frac{1}{2} \times 53\frac{1}{2}$ (70×136). Acq.no.2065.

42 *Sketch for 'Ulysses deriding Polyphemus'*, ?1828. Canvas, $23\frac{5}{8} \times 35\frac{1}{8}$ (60×89). Acq.no.2958.

43 *Rocky Bay with Figures*, c.1830. Canvas, 36×49 (91.5×124.5). Acq.no.1989.

44 *Fishing Boat in a Mist*, ?1828. Canvas, $23\frac{3}{4} \times 35\frac{3}{4}$ (60×91). Acq.no.3386.

45 *Lake Nemi*, ?1828. Canvas, $23\frac{3}{4} \times 39\frac{1}{4}$ (60.5×99). Acq.no.3027.

46 *Coast Scene near Naples*, ?1828. Millboard, $16\frac{1}{8} \times 23\frac{1}{2}$ (41×59.5). Acq.no.5527.

47 *Archway with Trees by the Sea*, ?1828. Canvas, $23\frac{5}{8} \times 34\frac{1}{4}$ (60×87.5). Acq.no.3381.

48 *Tivoli, the Cascatelle*, ?1828. Canvas, $23\frac{5}{8} \times 30\frac{5}{8}$ (60.5×78). Acq.no.3388.

49 *Tivoli: Tobias and the Angel*, c.1835. Canvas, $35\frac{5}{8} \times 47\frac{5}{8}$ (90.5×121). Acq.no.2067.

50 *Reclining Venus*, 1828. Canvas, 69×98 (175×249). Acq.no.5498.

51 *Vision of Medea*, 1828. Canvas, $68\frac{3}{8} \times 98$ (173.5×241). Acq.no.513.

52 *View of Orvieto, painted in Rome*, 1828; reworked and exh.1830. Canvas, $36 \times 48\frac{1}{2}$ (91.5×123). Acq.no.511.

53 *Regulus*, 1828; reworked and exh.1837. Canvas, $35\frac{1}{4} \times 48\frac{3}{4}$ (91×124). Acq.no.519.

54 *Italian Landscape, probably Civita di Bagnoregio*, ?1828. Canvas, $59 \times 98\frac{1}{4}$ (150×249.5). Acq.no.5473.

55 *Caligula's Palace and Bridge*, exh.1831. Canvas, 54×97 (137×246.5). Acq.no.512.

56 *The Thames above Waterloo Bridge*, c.1830–5. Canvas, $35\frac{5}{8} \times 47\frac{5}{8}$ (90.5×121). Acq.no.1992.

57 *Rough Sea with Wreckage*, c.1830–5. Canvas, $36\frac{1}{4} \times 48\frac{1}{4}$ (92×122.5). Acq.no.1980.

58 *Childe Harold's Pilgrimage – Italy*, exh.1823. Canvas, $56 \times 97\frac{3}{4}$ (142×248). Acq.no.516.

59 *Story of Apollo and Daphne*, exh.1837. Mahogany, $43\frac{1}{4} \times 78\frac{1}{4}$ (110×199). Acq.no.520.

60 *Harbour with Town and Fortress*, ?c.1830. Canvas, 66×88 (172.5×223.5). Acq.no.5514.

61 *Fire at Sea*, c.1835. Canvas, $67\frac{1}{2} \times 86\frac{3}{4}$ (171.5×220.5). Acq.no.558.

62 *Waves breaking on a Lee Shore*, c.1835. Canvas, $23\frac{1}{2} \times 37\frac{1}{2}$ (60×95). Acq.no.2882.

63 *Bridge of Sighs, Ducal Palace and Custom-House, Venice: Canaletti painting*, exh.1833. Mahogany, $20\frac{3}{16} \times 32\frac{7}{16}$ (51×82.5). Acq.no.370.

64 *Pilate washing his Hands*, exh.1830. Canvas, 36×48 (91.5×122). Acq.no.510.

65 *Interior at Petworth*, ?1837. Canvas, $35\frac{3}{4} \times 48$ (91.5×122). Acq.no.1988.

66 *Music Party, Petworth*, c.1835. Canvas, $47\frac{3}{4} \times 35\frac{5}{8}$ (121×90.5). Acq.no.3550.

67 *Two Women with a Letter*, c.1835. Canvas, 48×36 (122×91.5). Acq.no.5501.

68 *Norham Castle, Sunrise*, c.1835–40. Canvas, $35\frac{3}{4} \times 48$ (91×122). Acq.no.1981.

69 *Ancient Rome: Agrippina landing with the Ashes of Germanicus*, exh.1839. Canvas, 36×48 (91.5×122). Acq.no.523.

70 *Sunrise, with a Boat between Headlands*, c.1835–40. Canvas, 36×48 (91.5×122). Acq.no.2002.

71 *Sunrise, a Castle on a Bay: 'Solitude'*, c.1835–40. Canvas, $35\frac{3}{4} \times 48$ (91×122). Acq.no.1985.

72 *Yacht approaching the Coast*, c.1835–40. Canvas, $40\frac{1}{4} \times 56$ (102×142). Acq.no.4662.

73 *Sun setting over a Lake*, c.1840. Canvas, $35\frac{7}{8} \times 48\frac{1}{4}$ (91×122.5). Acq.no.4665.

74 *Mountain Landscape*, c.1835–40. Canvas, 28×38 (71×96.5). Acq.no.5486.

75 *Stormy Sea with Dolphins*, c.1835–40. Canvas, $35\frac{3}{4} \times 48$ (91×122). Acq.no.4664.

76 *Peace – Burial at Sea*, exh.1842. Canvas, $34\frac{1}{4} \times 34\frac{1}{8}$ (87×86.5). Acq.no.528.

77 *War. The Exile and the Rock Limpet*, exh.1842. Canvas, $31\frac{1}{4} \times 31\frac{1}{4}$ (79.5×79.5). Acq.no.529.

78 *The Dogana, San Giorgio, Citella, from the Steps of the Europa*, exh.1842. Canvas, $24\frac{1}{4} \times 36\frac{1}{2}$ (62×92.5). Acq.no.372.

79 *St Benedetto, looking towards Fusina*, exh.1843. Canvas, $24\frac{1}{2} \times 36\frac{1}{2}$ (62.5×92). Acq.no.534.

80 *Venice with the Salute*, c.1840–5. Canvas, $24\frac{1}{2} \times 36\frac{1}{2}$ (62×92.5). Acq.no.5487.

81 *The Sun of Venice going to Sea*, exh.1843. Canvas, $24\frac{1}{4} \times 36\frac{1}{4}$ (61.5×92). Acq.no.535.

82 *Rough Sea*, c.1840–5. Canvas, 36×48 (91.5×122). Acq.no.5479.

83 *Snow Storm – Steam-Boat off a Harbour's Mouth*, exh.1842. Canvas, 36×48 (91.5×122). Acq.no.530.

84 *Shade and Darkness – The Evening of the Deluge*, exh.1843. Canvas, $31 \times 30\frac{3}{4}$ (78.5×78). Acq.no.531.

85 *Light and Colour (Goethe's Theory) – The Morning after the Deluge – Moses writing the Book of Genesis*, exh.1843. Canvas, 31×31 (78.5×78.5). Acq.no.532.

86 *Procession of Boats with Distant Smoke, Venice*, c.1845. Canvas, $35\frac{1}{2} \times 47\frac{1}{2}$ (90×120.5). Acq.no.2068.

87 *Heidelberg*, c.1840–5. Canvas, $52 \times 79\frac{1}{2}$ (132×201). Acq.no.518.

88 *Sunrise with Sea Monsters*, c.1845. Canvas, 36×48 (91.5×122). Acq.no.1990.

89 *Whalers*, exh.1845. Canvas, $35\frac{7}{8} \times 48$ (91×122). Acq.no.545.

90 *The Hero of a Hundred Fights*, c.1800–10; reworked and exh.1847. Canvas, $35\frac{3}{4} \times 47\frac{3}{4}$ (91×121). Acq.no.551.

91 *Mercury sent to admonish Æneas*, exh.1850. Canvas, $35\frac{1}{2} \times 47\frac{1}{2}$ (90.5×121). Acq.no.553.

92 *The Angel standing in the Sun*, exh.1846. Canvas, 31×31 (78.5×78.5). Acq.no.550.

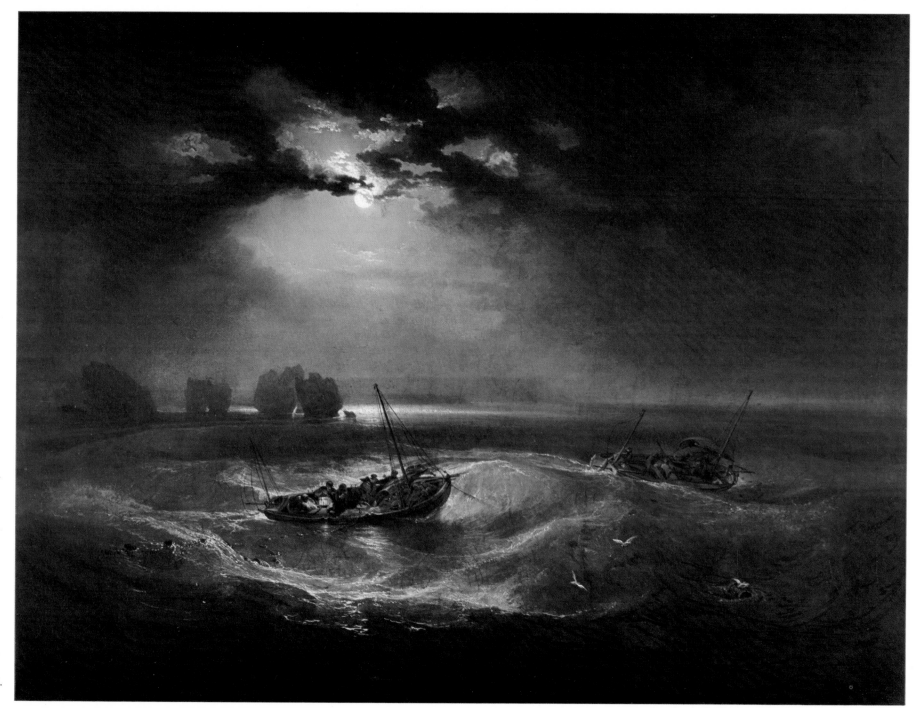

FISHERMEN AT SEA,
exh.1796. Canvas,
$36 \times 48\frac{1}{8}$ (91.5×122.4).
Acq.no.T.1585.

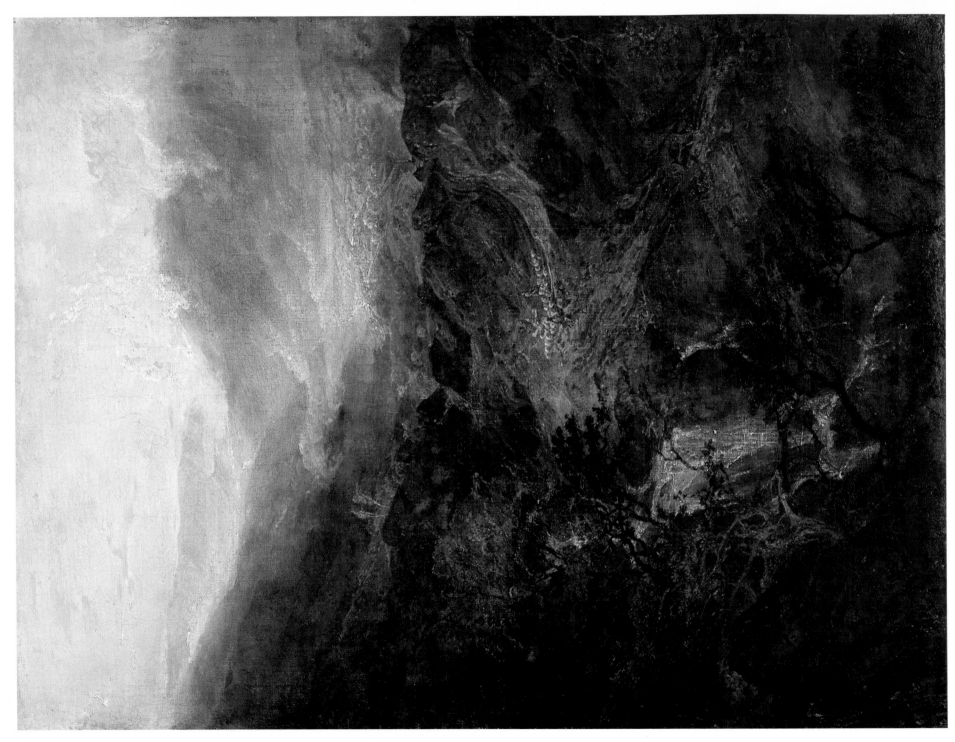

2. MORNING AMONGST THE CONISTON FELLS, CUMBERLAND, exh.1798. Canvas, $48\frac{3}{8} \times 35\frac{5}{16}$ (123×89.7). Acq.no.461.

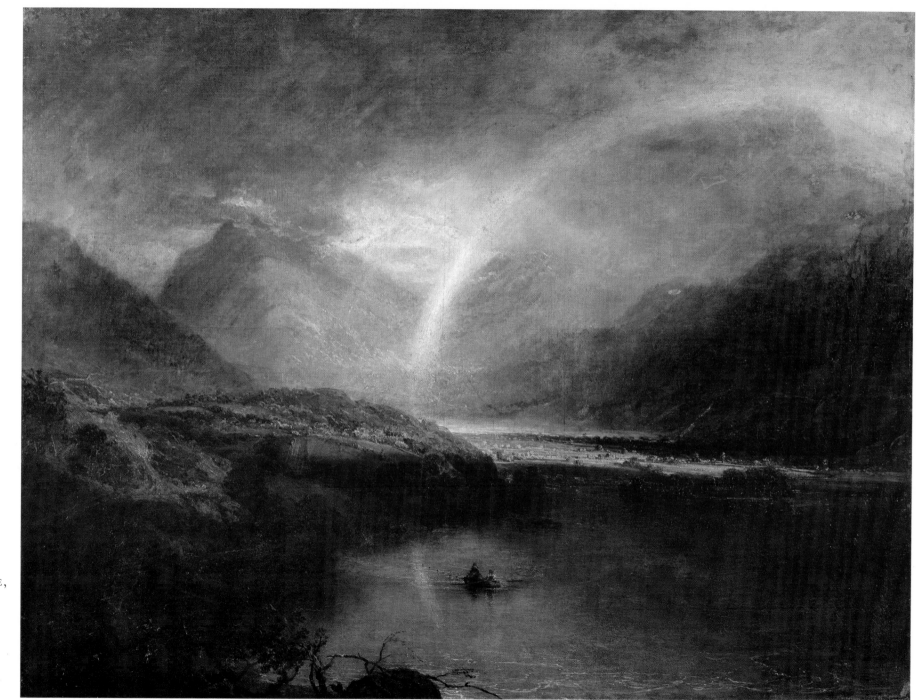

. BUTTERMERE LAKE,
WITH PART OF
CROMACKWATER,
CUMBERLAND,
A SHOWER,
exh. 1798. Canvas,
36½ × 48 (91.5 × 122).
Acq. no. 460.

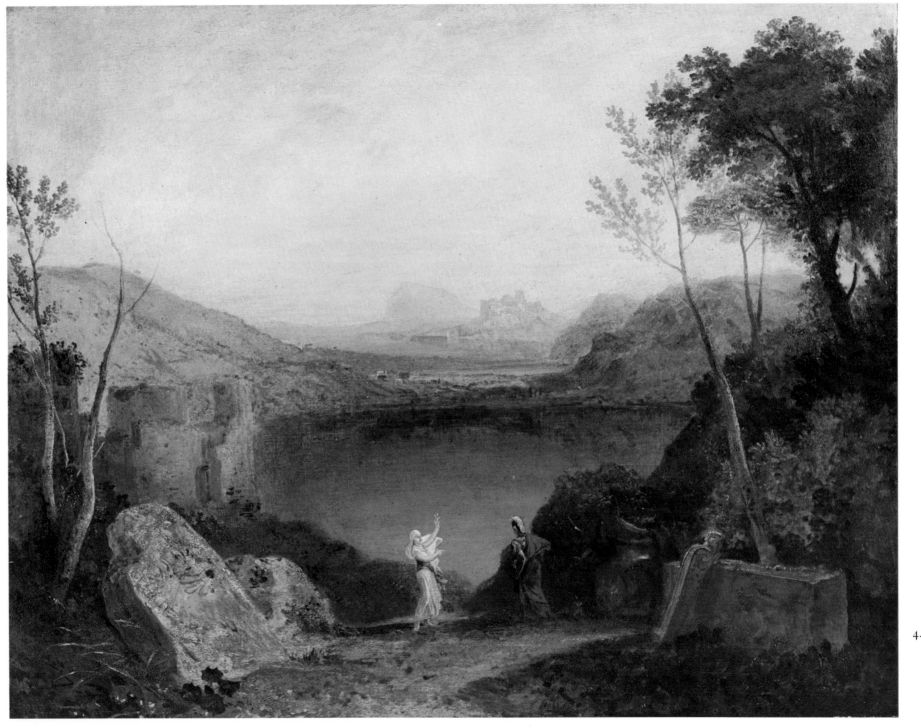

4. AENEAS AND
THE SIBYL, LAKE
AVERNUS, *c*.1798.
Canvas, $30\frac{1}{8} \times 38\frac{3}{4}$
(76.5×98.5).
Acq.no.463.

5. VIEW ON CLAPHAM COMMON, *c*.1800–5. Mahogany, $12\frac{5}{8} \times 17\frac{7}{16}$ (32×44.5). Acq.no.468.

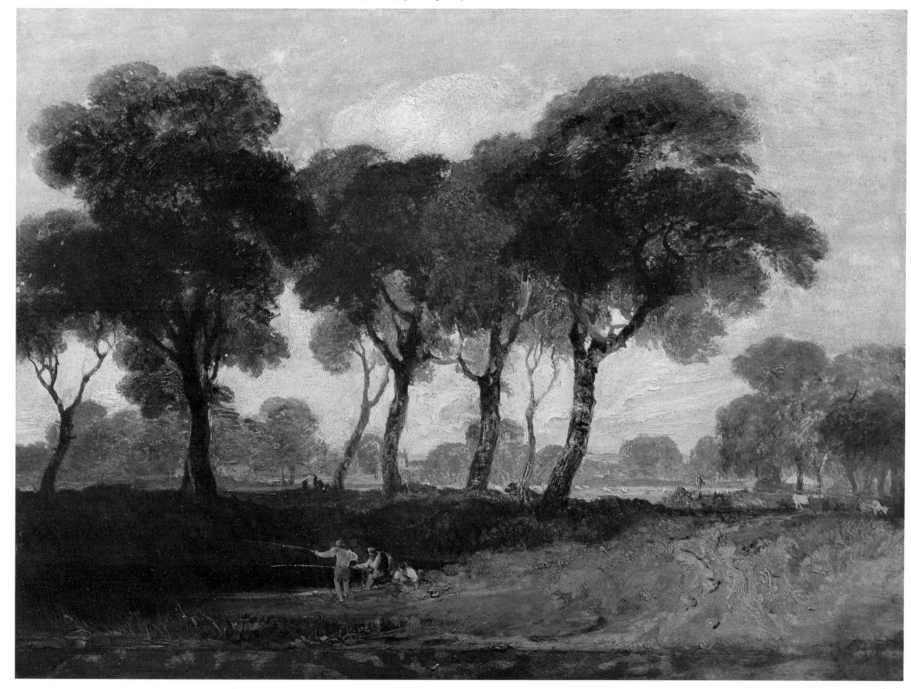

6. THE SHIPWRECK, exh.1805. Canvas, $67\frac{1}{8} \times 95\frac{1}{8}$ (170.5 × 241.5). Acq.no.476.

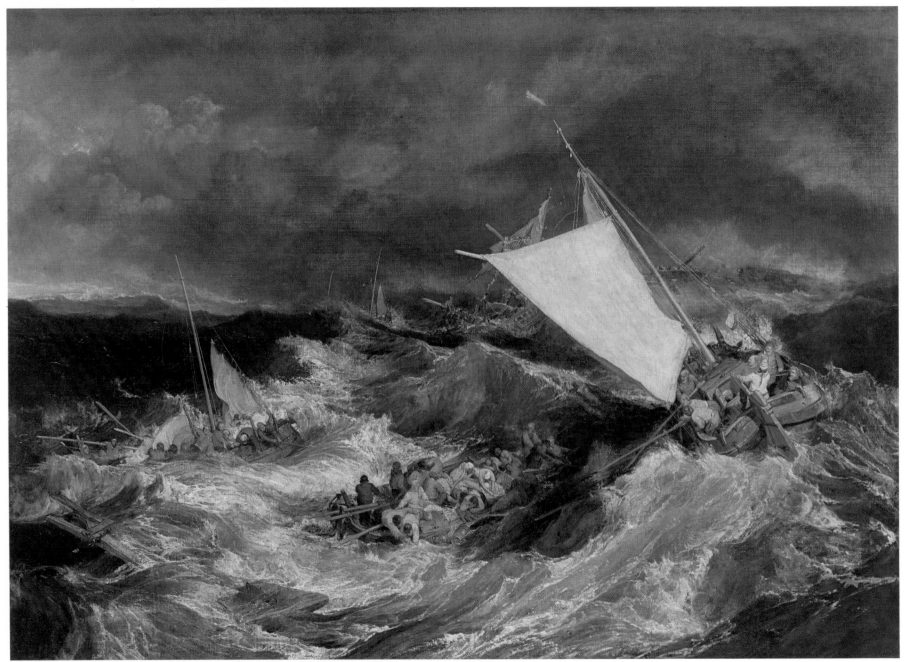

7. THE BATTLE OF TRAFALGAR, AS SEEN FROM THE MIZEN STARBOARD SHROUDS OF THE VICTORY,
exh.1806; reworked and exh.1808. Canvas, $67\frac{1}{4} \times 94$ (171×239). Acq.no.480.

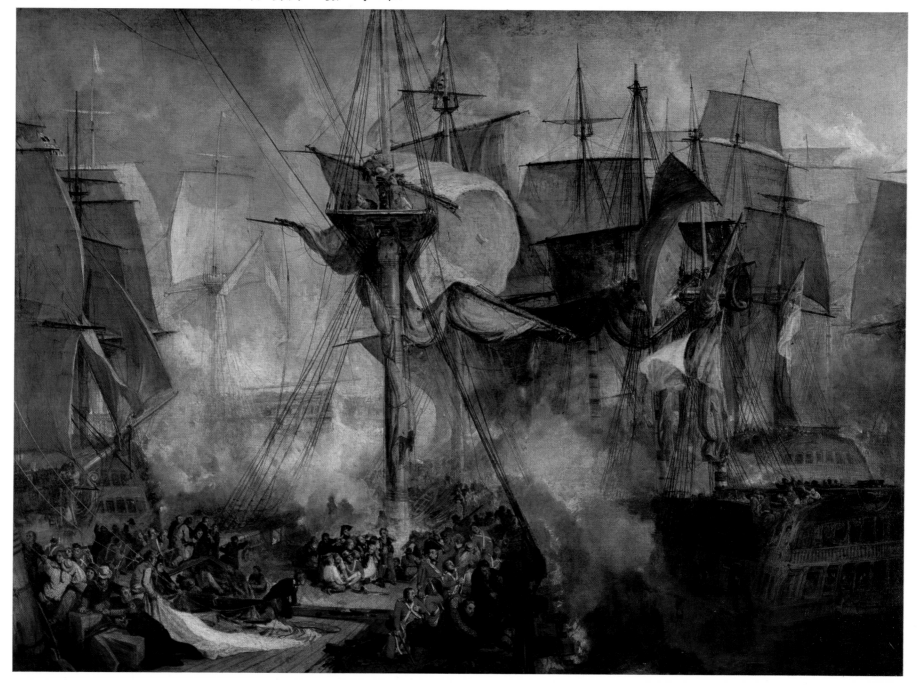

8. THE GODDESS OF DISCORD CHOOSING THE APPLE OF CONTENTION IN THE GARDEN OF THE HESPERIDES, exh.1806. Canvas, $61\frac{1}{8} \times 86$ (155×218.5). Acq.no.477.

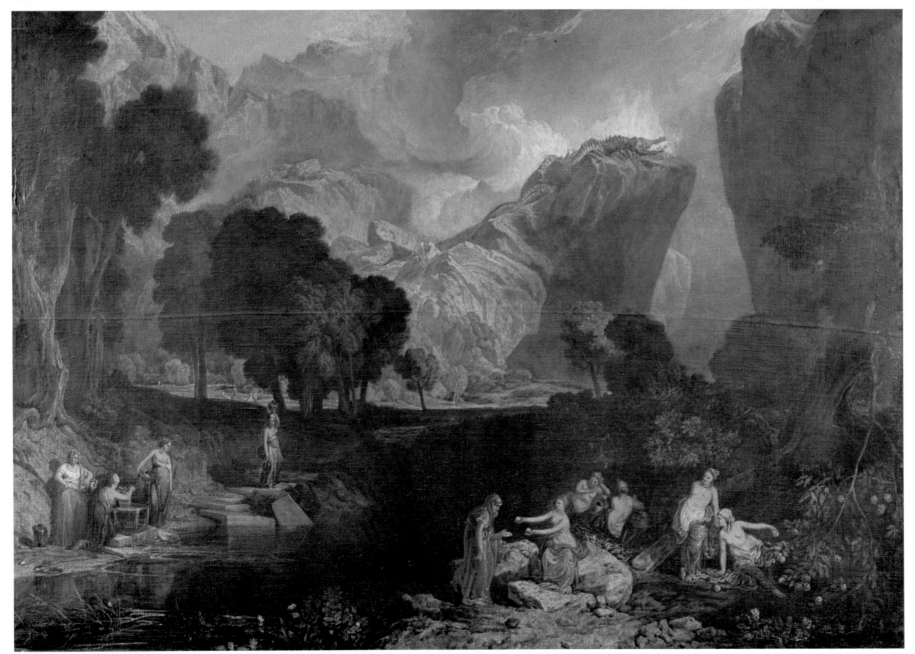

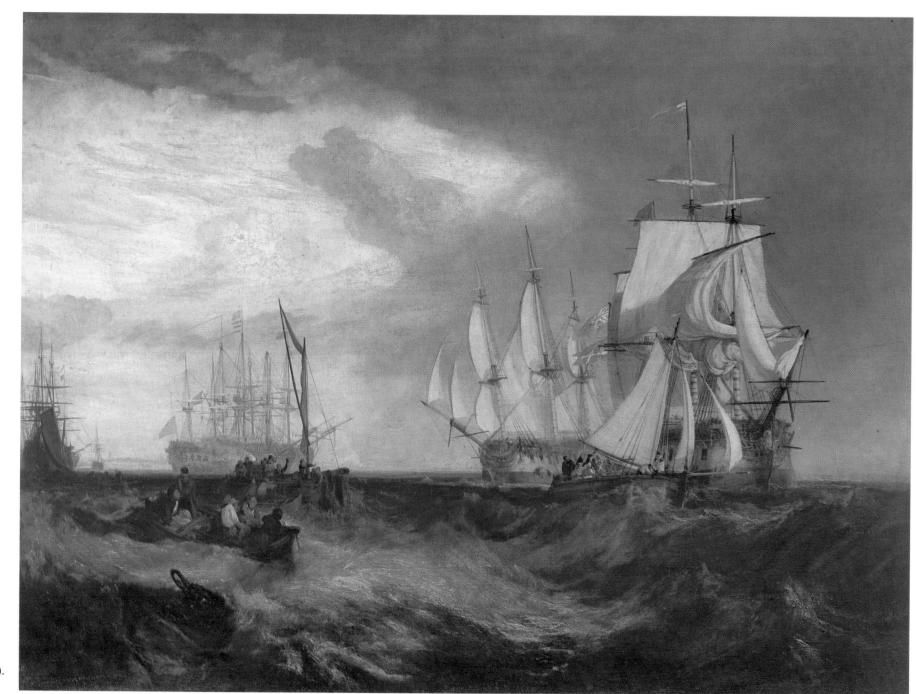

SPITHEAD: BOAT'S
CREW RECOVERING
AN ANCHOR,
exh. 1808. Canvas,
$67\frac{1}{2} \times 92\frac{5}{8}$ (171.5 × 235).
Acq.no.481.

10. A COUNTRY BLACKSMITH DISPUTING UPON THE PRICE OF IRON, exh.1807. Pine, $21\frac{5}{8} \times 30\frac{5}{8}$ (55×78). Acq.no.478.

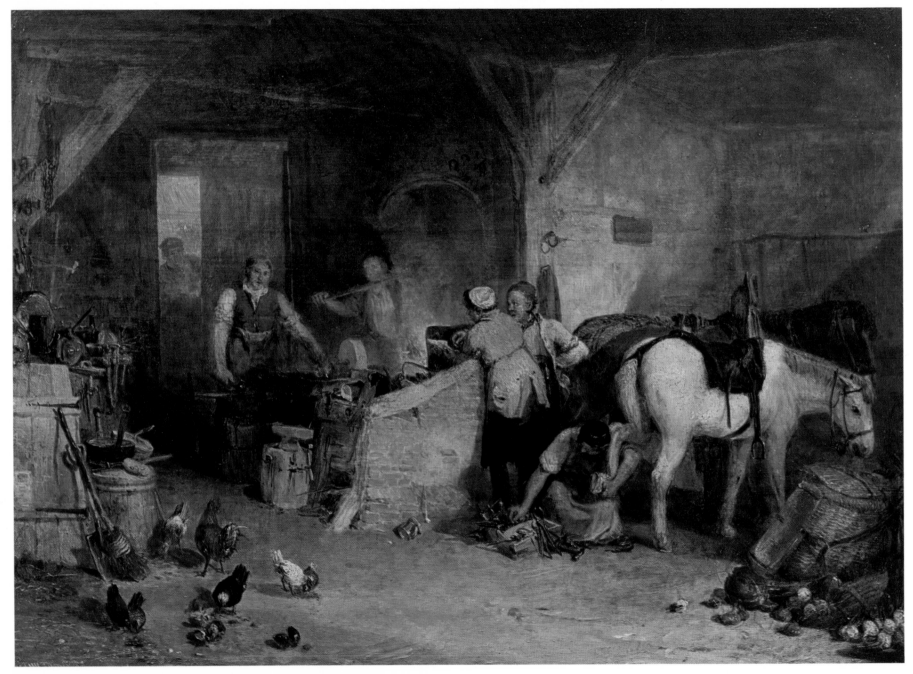

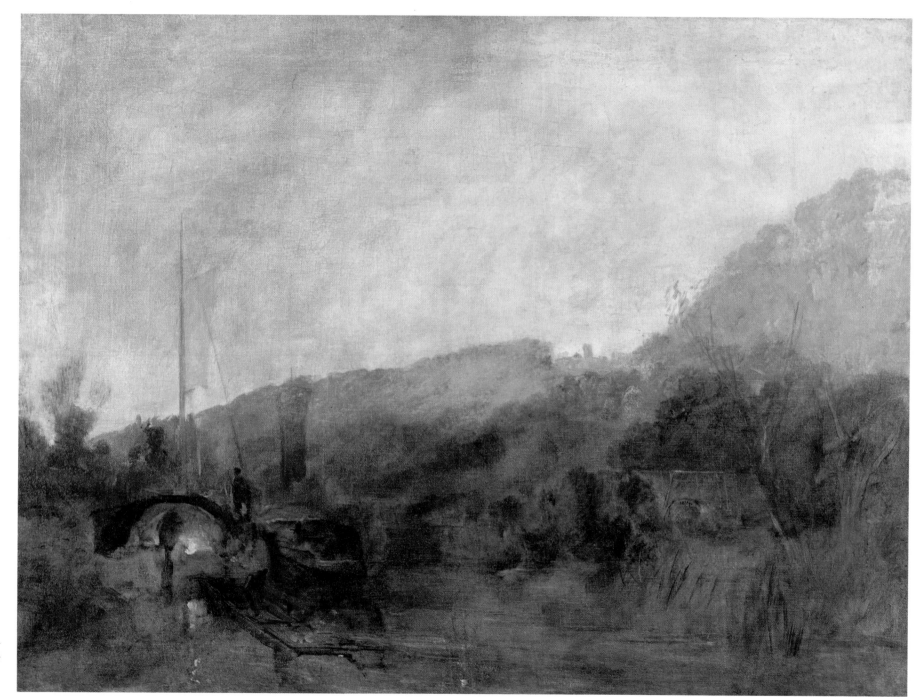

11. BARGE ON THE
RIVER, *c.*1806–7.
Canvas, 33½×45¾
(85×116).
Acq.no.2707.

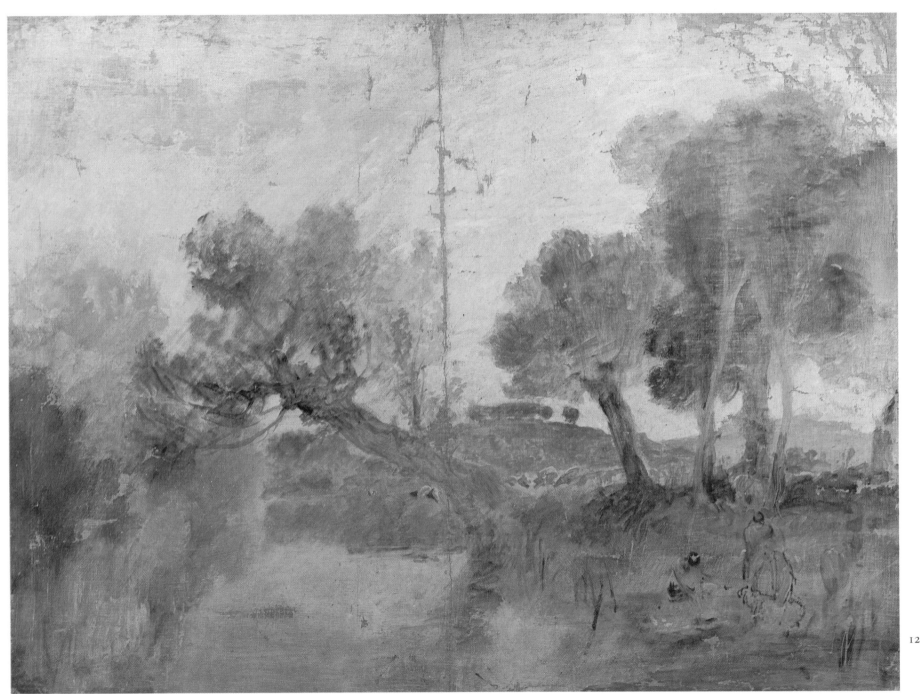

12. WASHING SHEEP,
c.1806–7. Canvas,
$33\frac{1}{4} \times 45\frac{7}{8}$ (84.5 × 116.
Acq.no.2699.

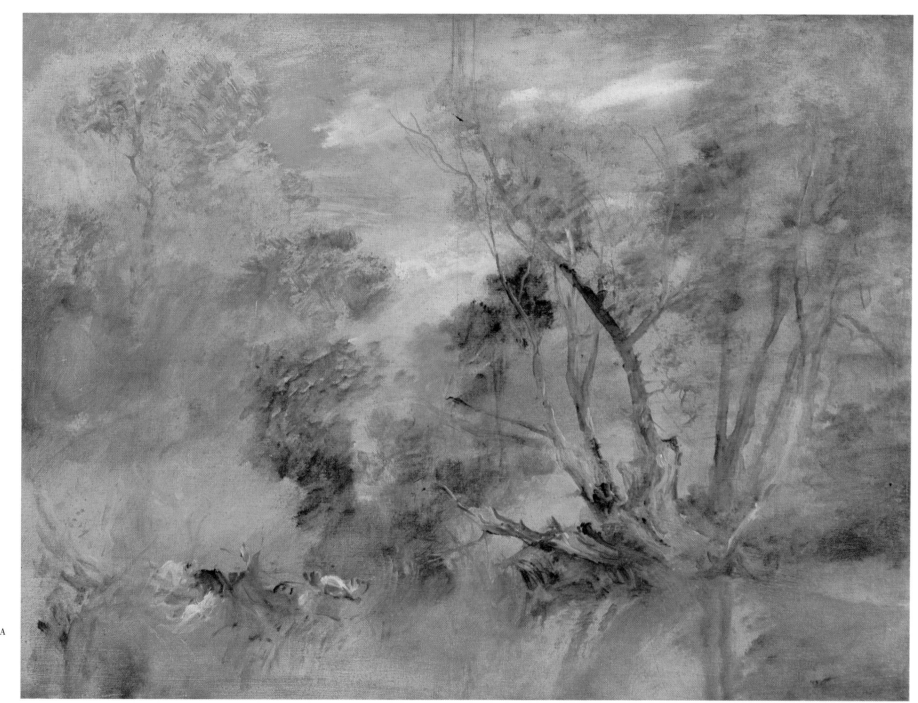

3. WILLOWS BESIDE A
STREAM, *c*.1806–7.
Canvas, $33\frac{7}{8} \times 45\frac{3}{4}$
(86×116.5).
Acq.no.2706.

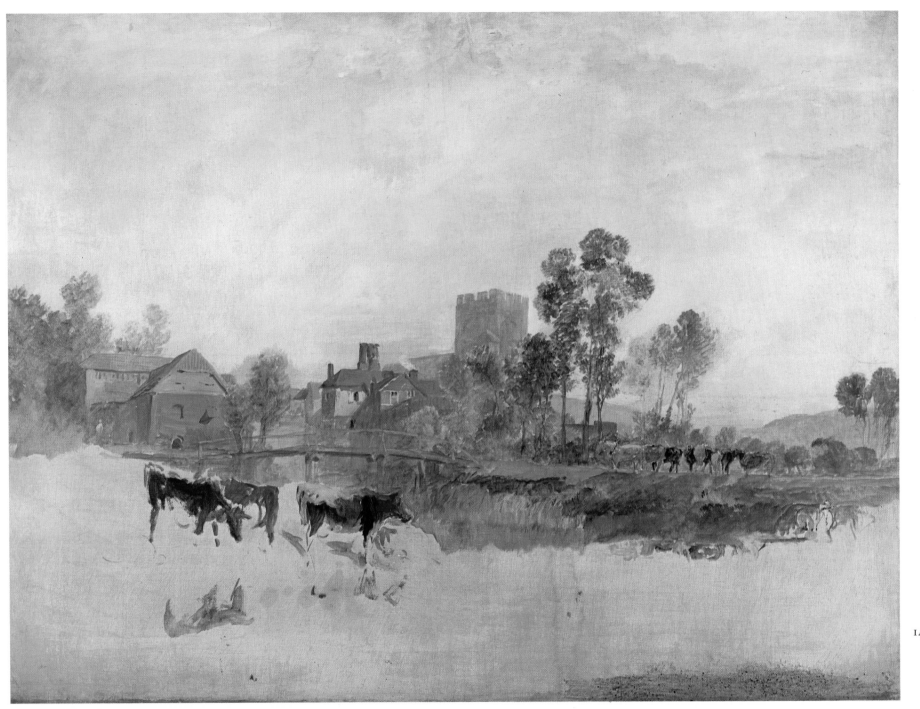

14. GORING MILL AND
CHURCH, *c.*1806–7.
Canvas, $33\frac{3}{4} \times 45\frac{3}{4}$
(85.5×116).
Acq.no.2704.

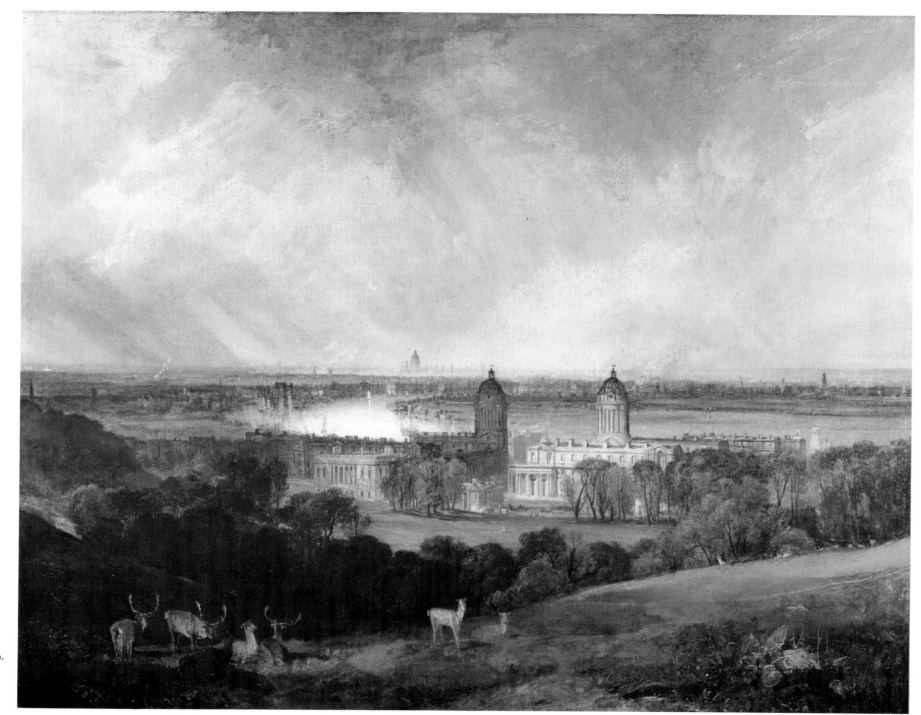

5. LONDON, exh. 1809.
Canvas, $35\frac{1}{2} \times 47\frac{1}{4}$
(90×120).
Acq.no.483.

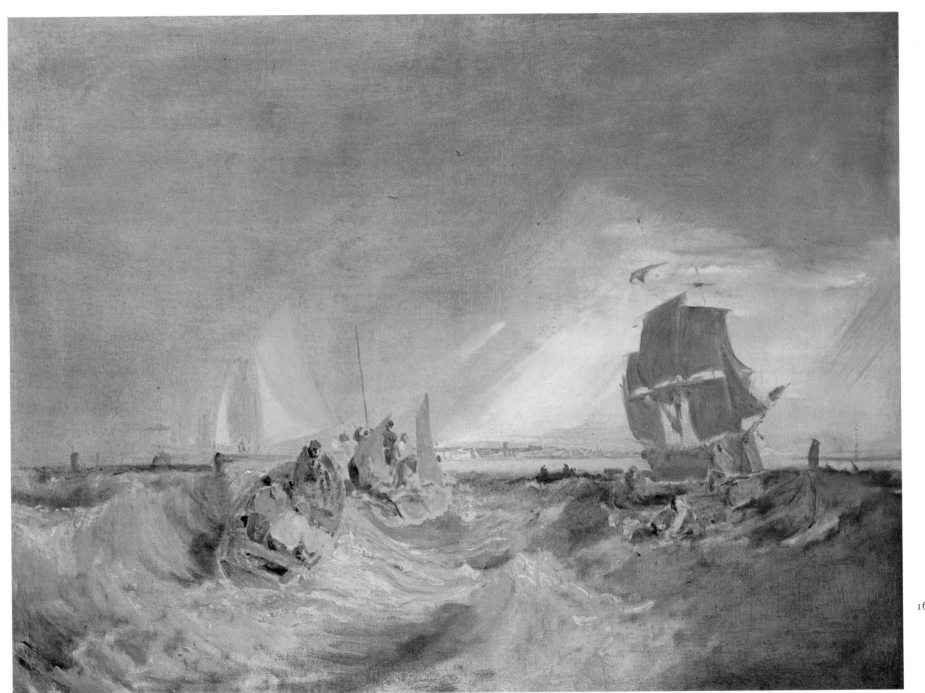

16. SHIPPING AT THE
MOUTH OF THE
THAMES, *c*.1806–7.
Canvas, $33\frac{3}{4} \times 46$
(86×117).
Acq.no.2702.

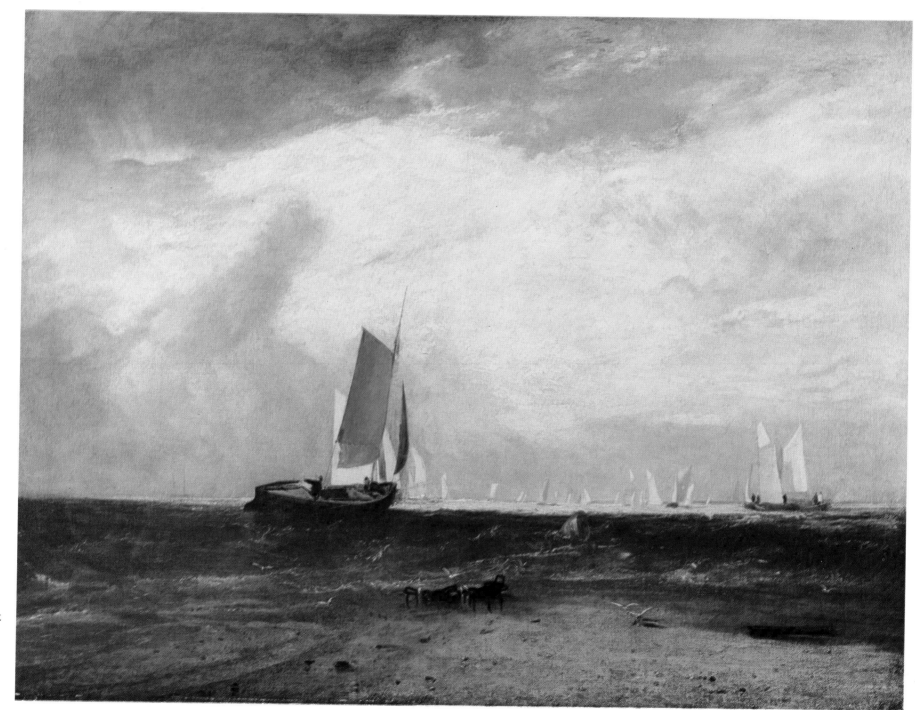

FISHING UPON THE
BLYTHE-SAND,
TIDE SETTING IN,
exh. 1809. Canvas,
35×47 (89×119.5).
Acq. no. 496.

18. WINDSOR CASTLE FROM SALT HILL, *c.*1807. Mahogany veneer, $10\frac{7}{8} \times 29$ (27×73.5). Acq.no.2312.

19. THE THAMES NEAR WALTON BRIDGES, *c.*1807. Mahogany veneer, 14⅝×29 (37×73.5). Acq.no.2680.

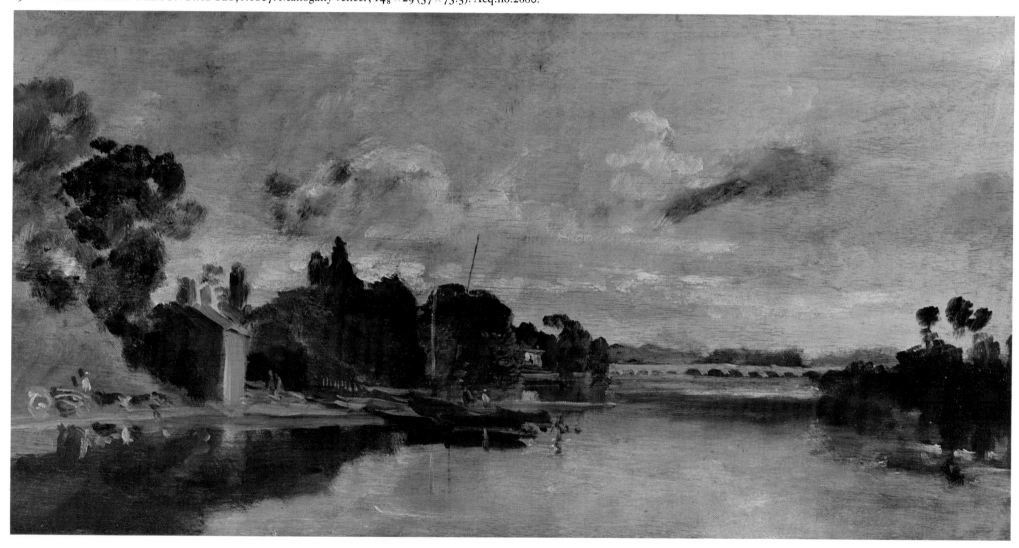

20. TREE TOPS AND SKY, GUILDFORD CASTLE ?, EVENING, $c.1807$. Mahogany veneer, $10\frac{7}{8} \times 29$ (27.5×73.5). Acq.no.2309.

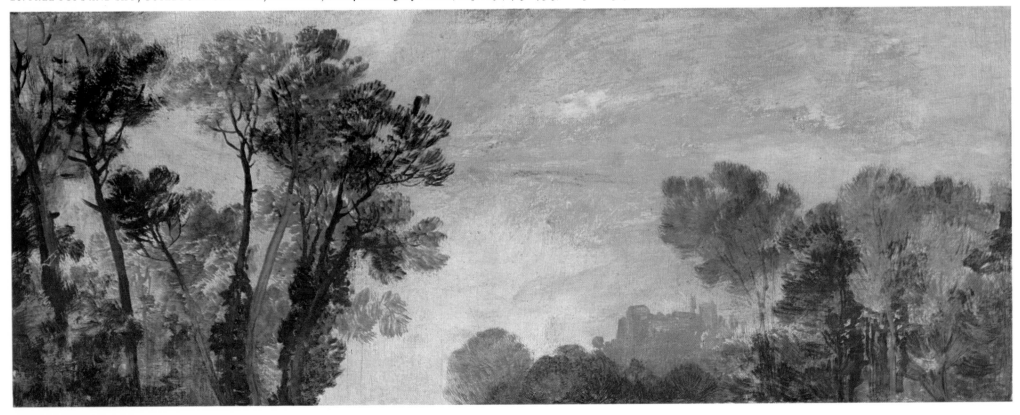

21. GODALMING FROM THE SOUTH, *c*.1807. Mahogany veneer, $8 \times 13\frac{3}{4}$ (20×35). Acq.no.2304.

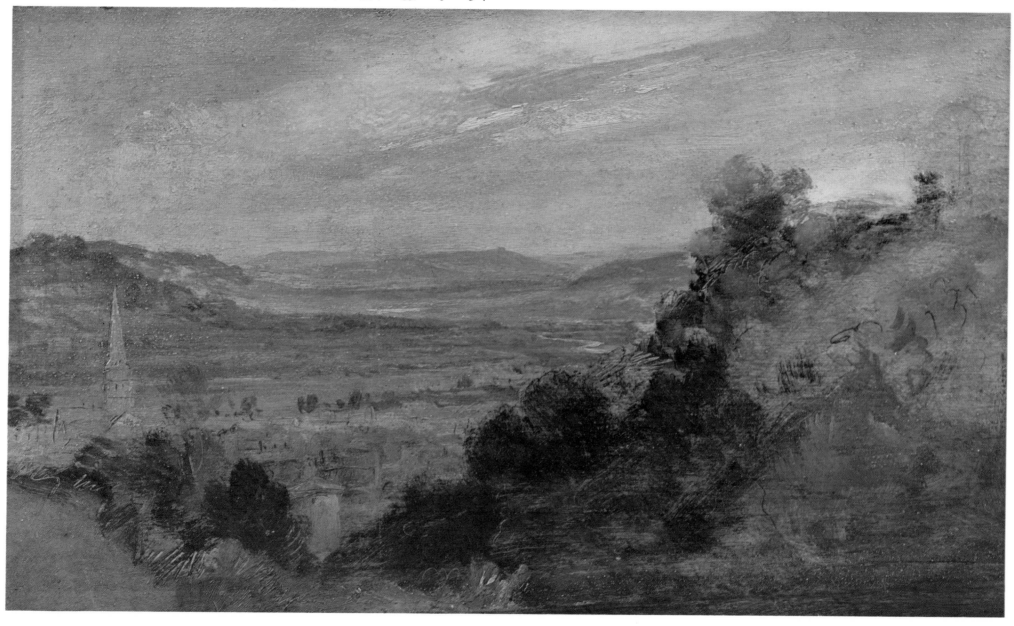

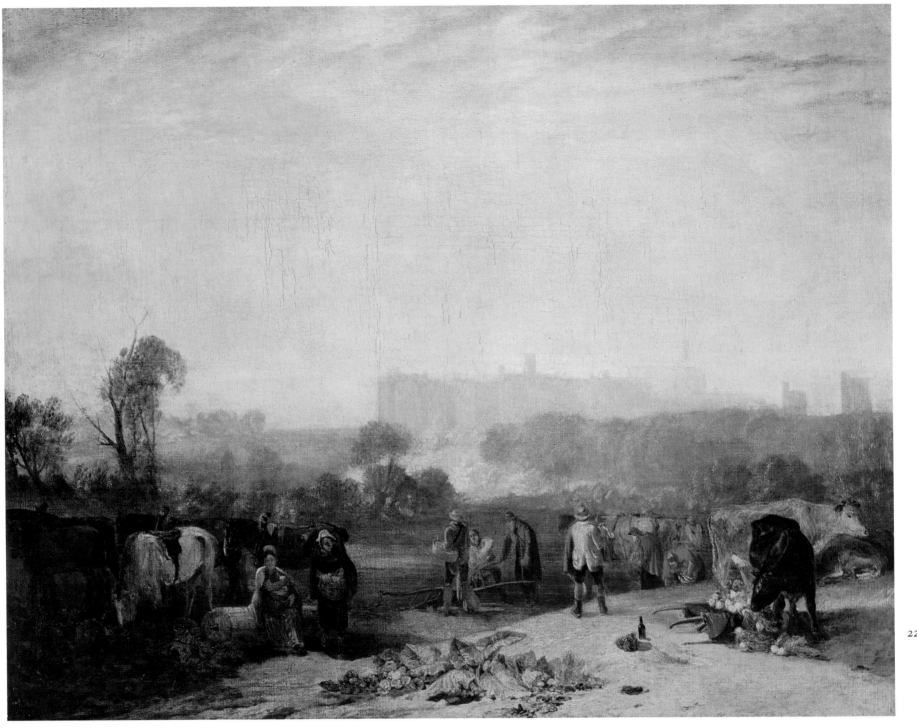

22. PLOUGHING UP
TURNIPS, NEAR
SLOUGH, exh. 1809.
Canvas, $40\frac{1}{8} \times 51\frac{1}{4}$
(102×130).
Acq.no.486.

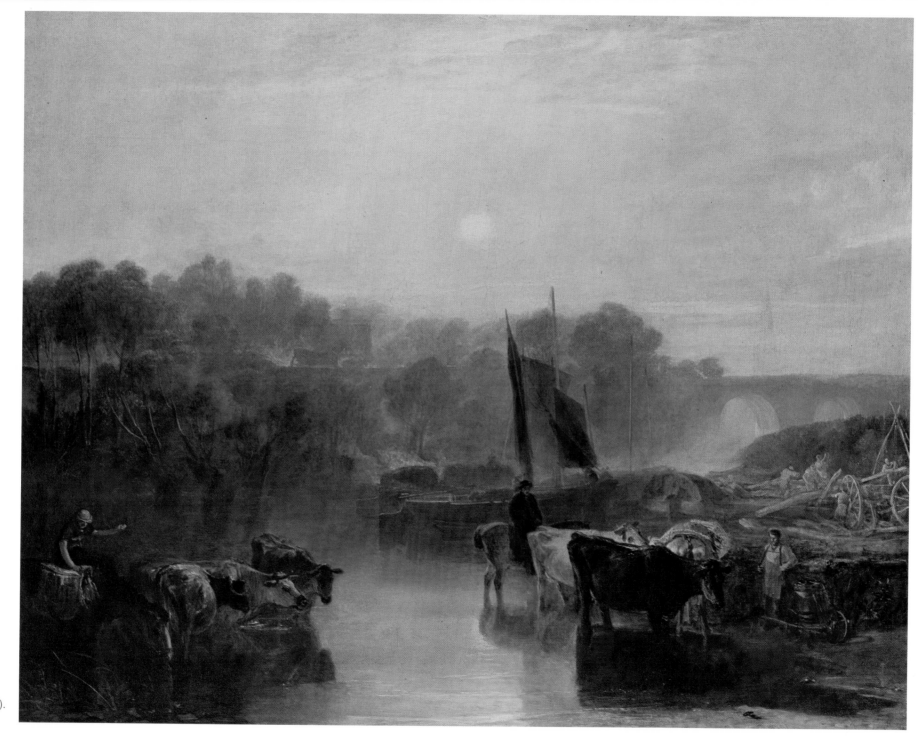

. DORCHESTER
MEAD,
OXFORDSHIRE,
exh. 1810. Canvas,
$40 \times 51\frac{1}{4}$ (101.5 × 130).
Acq.no.485.

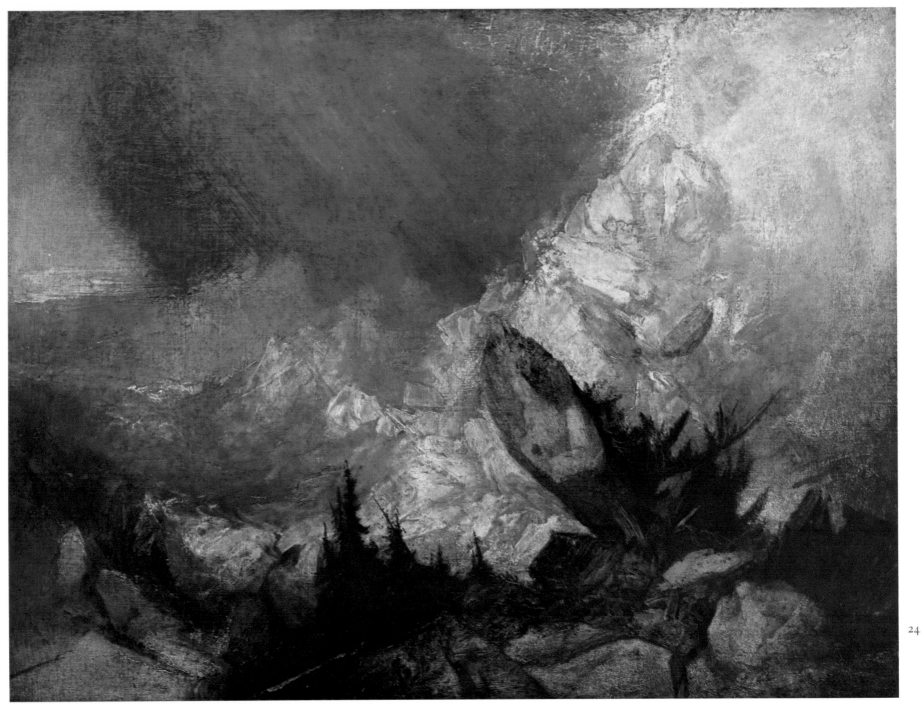

24. THE FALL OF AN
AVALANCHE IN THE
GRISONS, exh. 1810.
Canvas, $35\frac{1}{2} \times 47\frac{1}{4}$
(90 × 120). Acq.no.48

25. SNOW STORM: HANNIBAL AND HIS ARMY CROSSING THE ALPS, exh.1812. Canvas, $57\frac{1}{2} \times 93\frac{1}{2}$ (146×237.5). Acq.no.490.

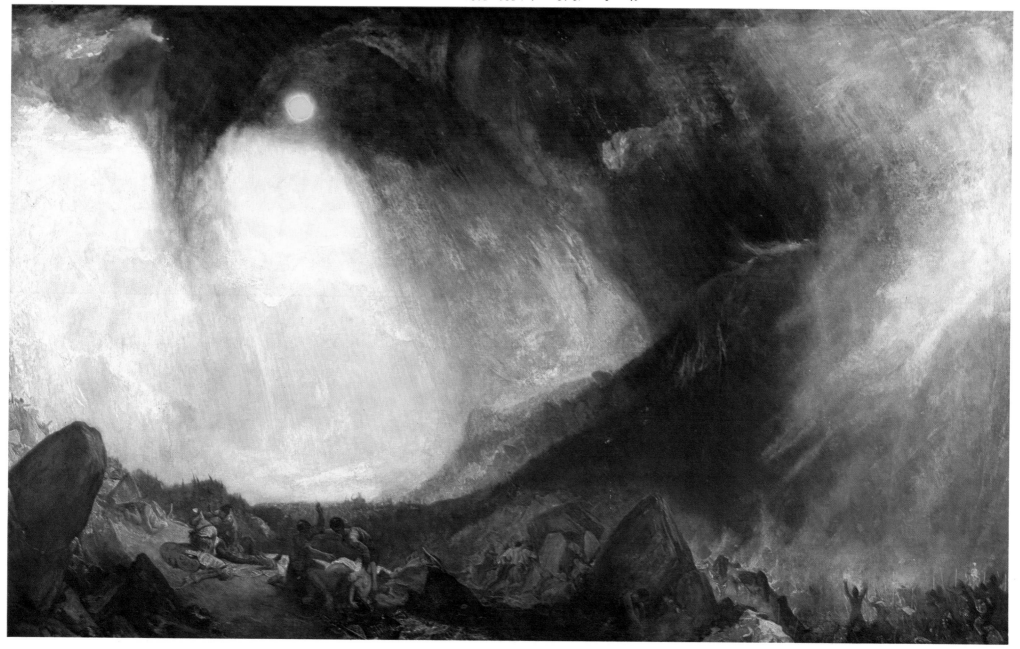

26. FROSTY MORNING, exh.1813. Canvas, $44\frac{3}{4} \times 68\frac{3}{4}$ (113.5 × 174.5). Acq.no.492.

27. THE DECLINE OF THE CARTHAGINIAN EMPIRE, exh. 1817. Canvas, 67 × 94 (170 × 238.5). Acq. no. 499.

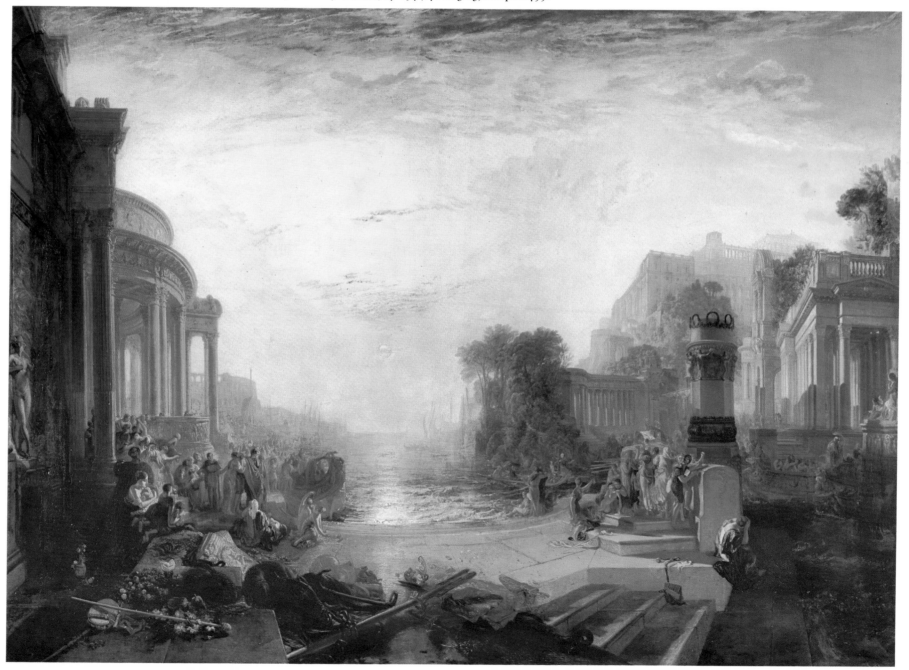

28. SUNSET ON THE RIVER, c.1807. Mahogany veneer, $6\frac{1}{16} \times 7\frac{5}{16}$ (15.5 × 18.5). Acq.no.2311.

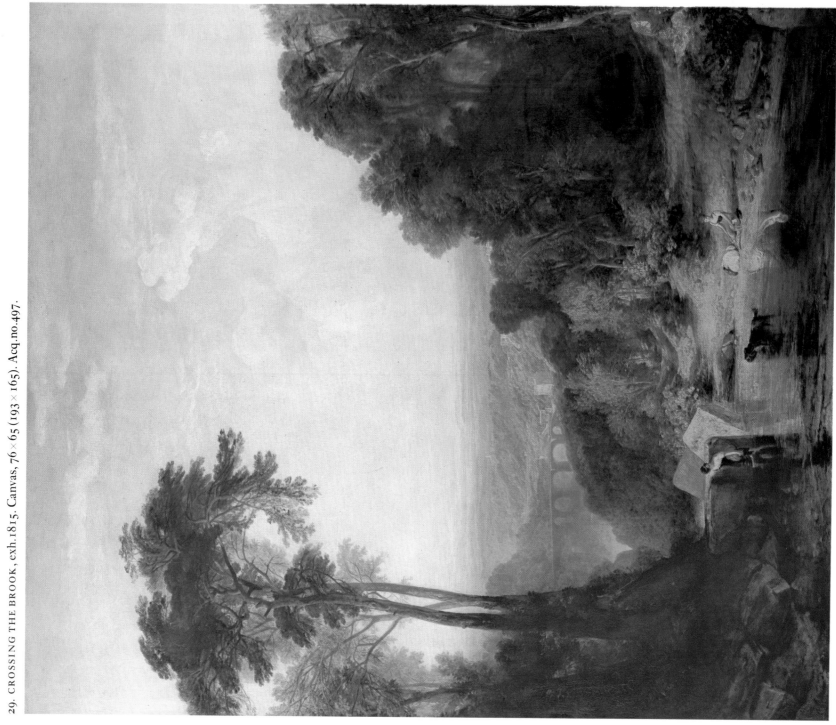

29. CROSSING THE BROOK, exh.1815. Canvas, 76 × 65 (193 × 165). Acq.no.497.

30. ENTRANCE OF THE MEUSE: ORANGE-MERCHANT ON THE BAR, GOING TO PIECES, exh.1819. Canvas, 69×97 (175.5×246.5). Acq.no.501.

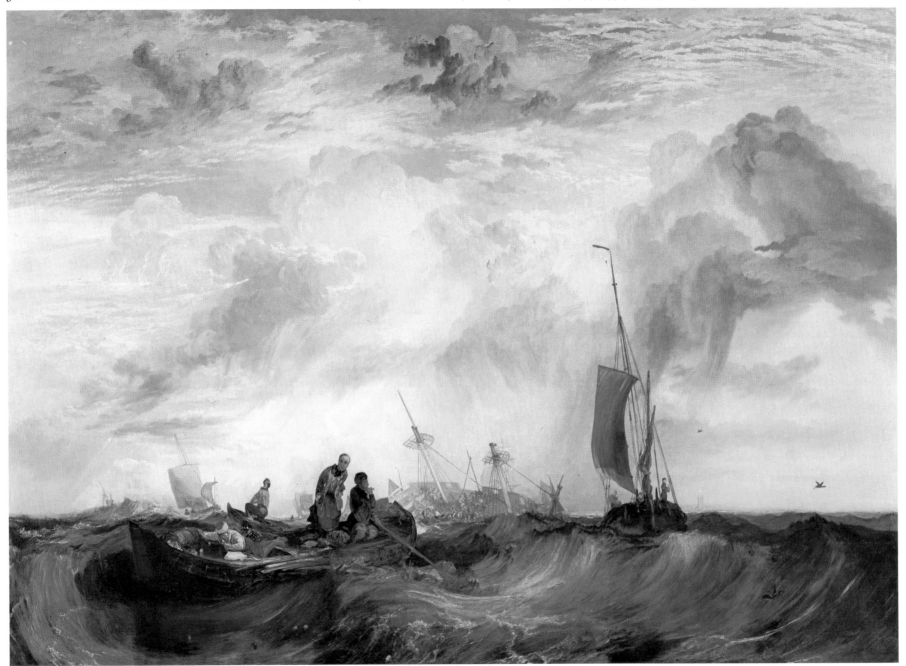

31. ENGLAND: RICHMOND HILL, ON THE PRINCE REGENT'S BIRTHDAY, exh.1819. Canvas, $70\frac{7}{8} \times 131\frac{3}{4}$ (180 × 334.5). Acq.no.502.

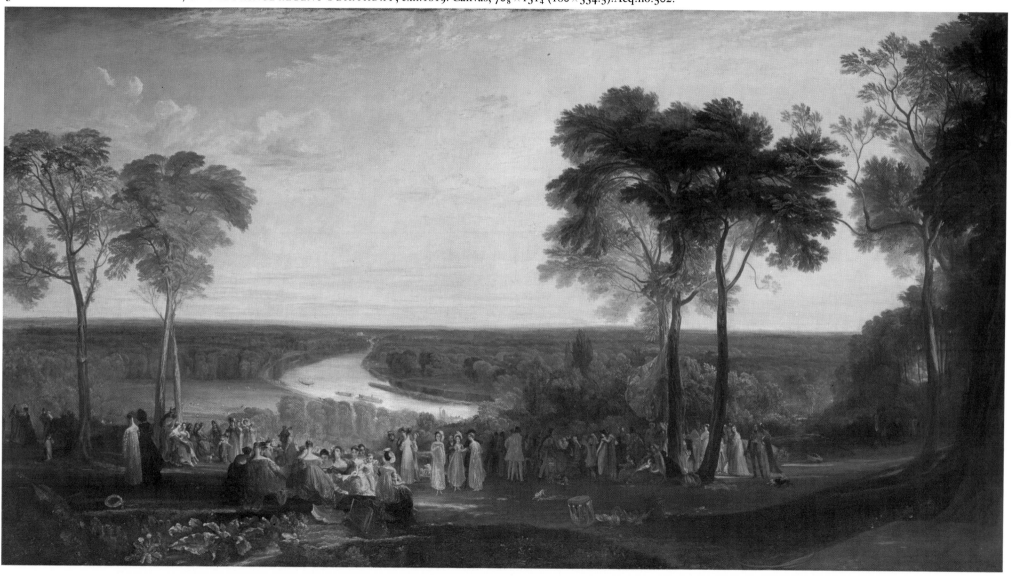

32. ROME, FROM THE VATICAN. RAFFAELLE, ACCOMPANIED BY LA FORNARINA, PREPARING HIS PICTURES FOR THE
DECORATION OF THE LOGGIA, exh.1820. Canvas, $69\frac{3}{4} \times 132$ (177×335.5). Acq.no.503.

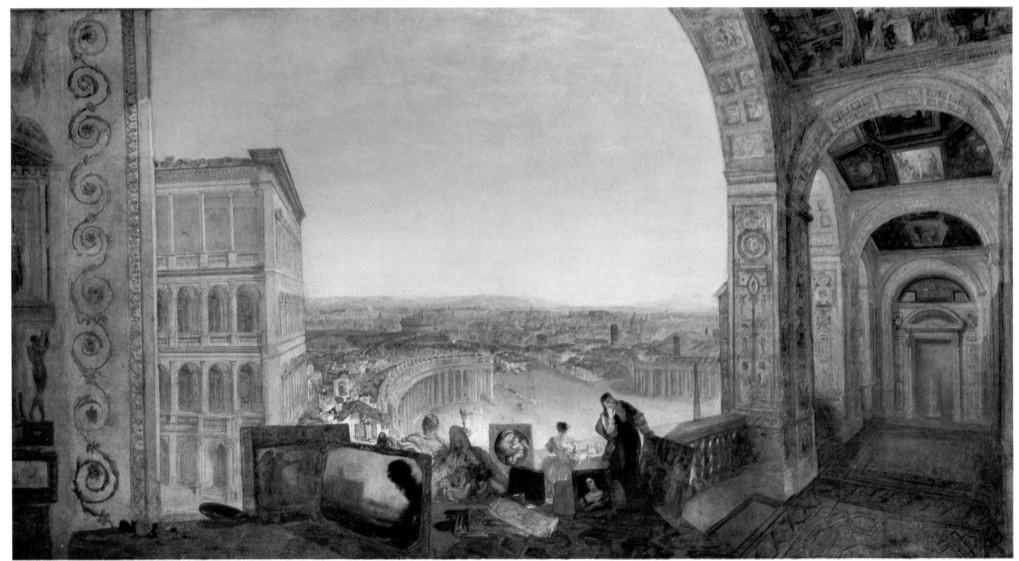

33. THE BAY OF BAIAE, WITH APOLLO AND THE SIBYL, exh.1823. Canvas, 57¼ × 94 (145.5 × 239). Acq.no.505.

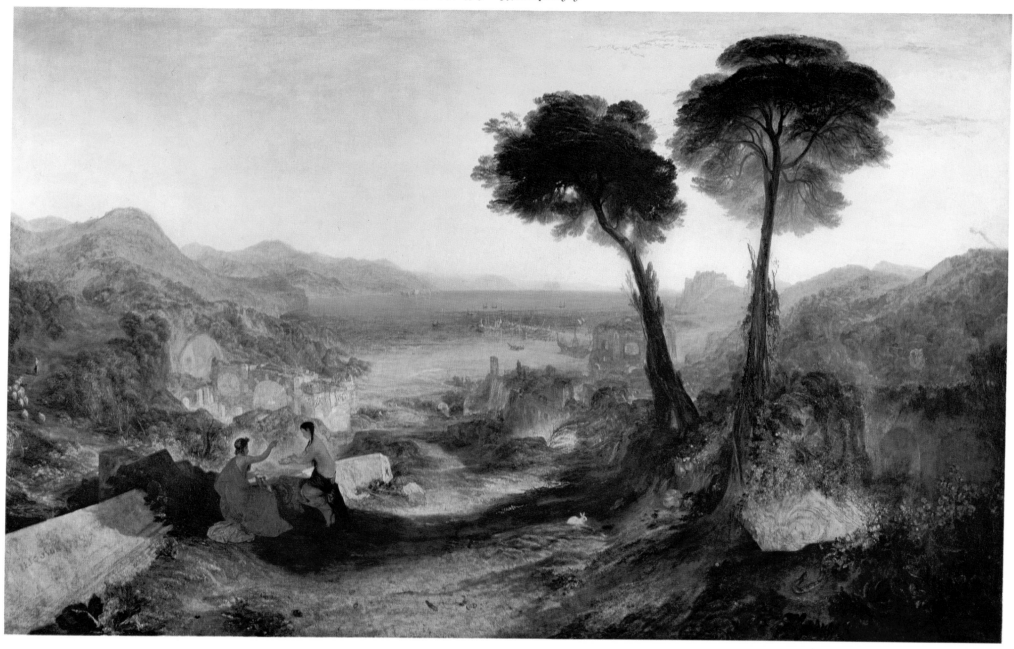

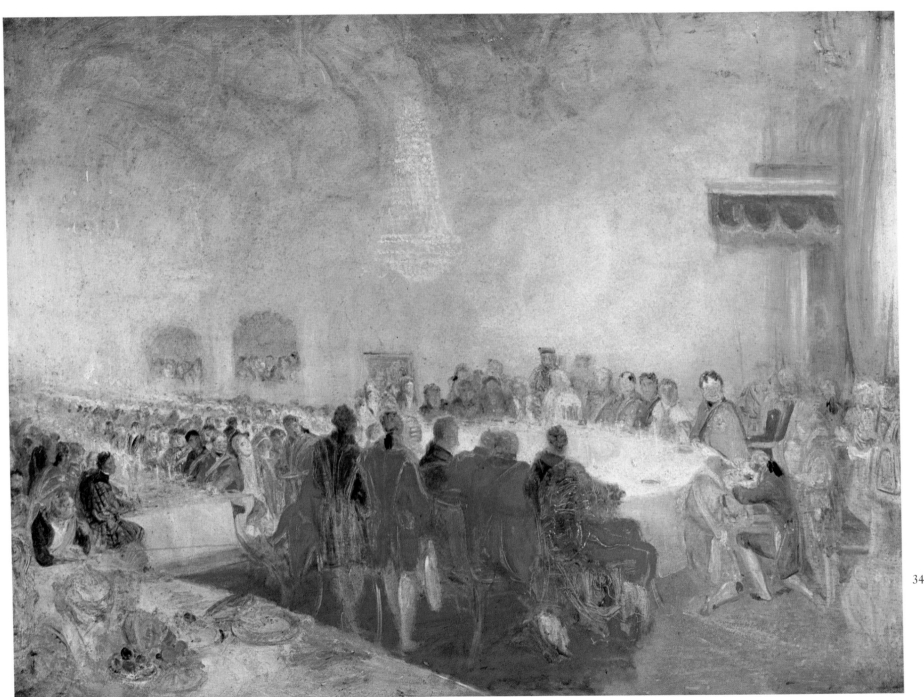

34. GEORGE IV AT TH
PROVOST'S BAN–
QUET IN THE
PARLIAMENT
HOUSE, EDINBUF
c.1822. Mahogany
$27 \times 36\frac{1}{8}$ (68.5 × 91
Acq.no.2858.

35. FORUM ROMANUM, FOR MR SOANE'S MUSEUM, exh. 1826. Canvas, $57\frac{3}{8} \times 93$ (145.5 × 237.5). Acq. no. 504.

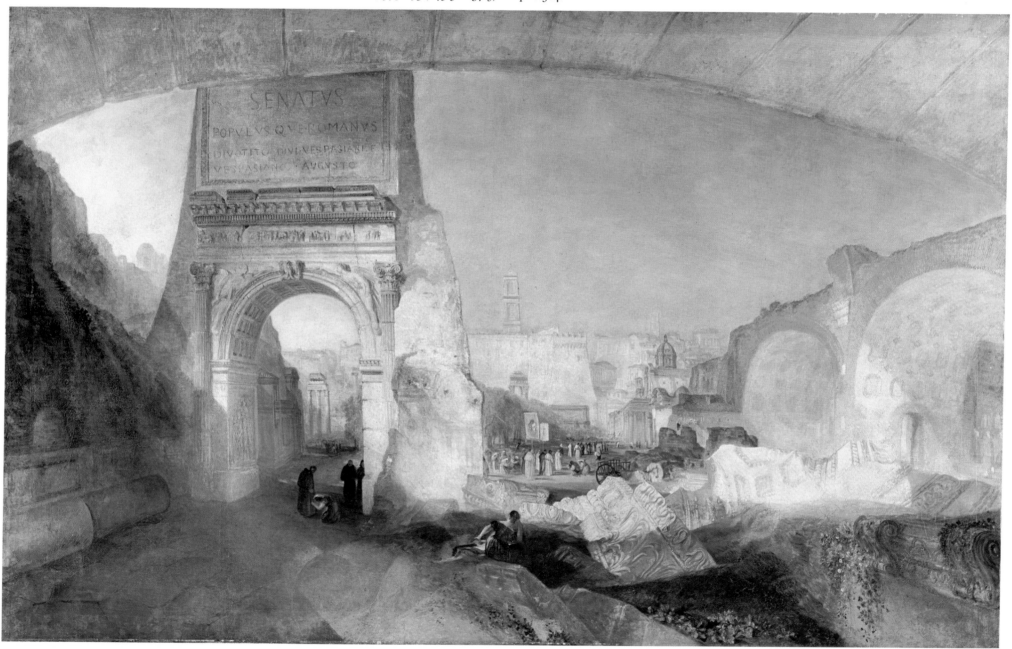

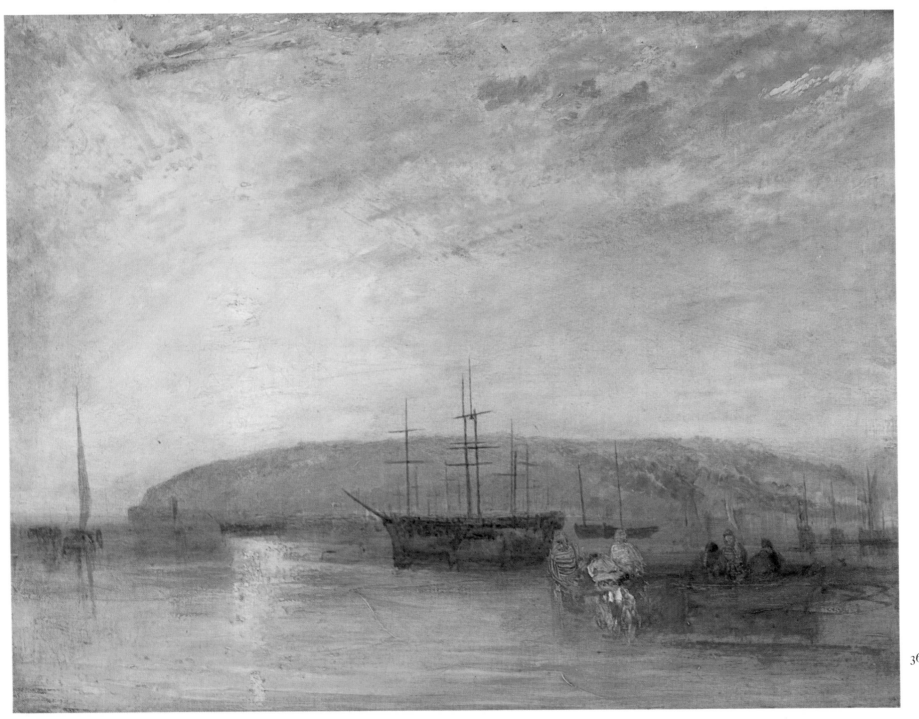

36. SHIPPING OFF EAS
COWES HEADLAND
1827. Canvas, $18\frac{1}{8}\times$
(46×60). Acq.no.19

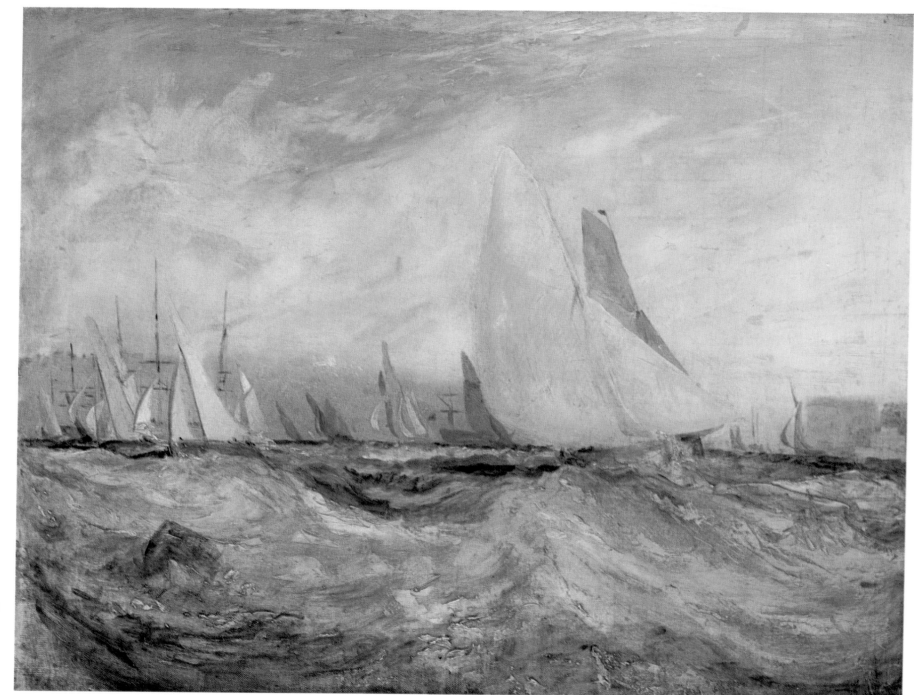

SKETCH FOR 'EAST
COWES CASTLE, THE
REGATTA BEATING
TO WINDWARD'
NO. 2, 1827. Canvas,
$17\frac{3}{4} \times 23\frac{7}{8}$ (45 × 60.5).
Acq.no.1994.

38. CHICHESTER CANAL, *c.*1828. Canvas, $25\frac{3}{4} \times 53$ (65.5 × 134.5). Acq.no.560.

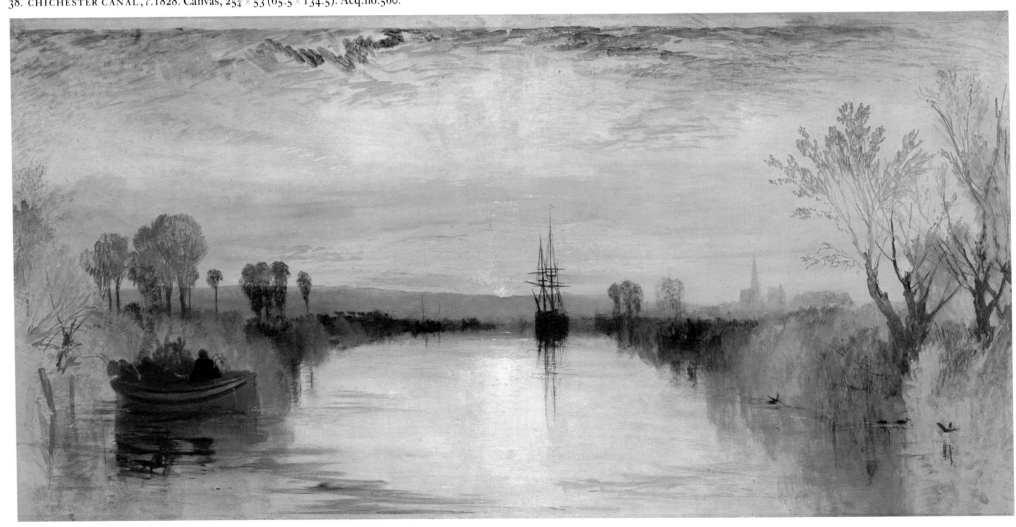

39. PETWORTH PARK: TILLINGTON CHURCH IN THE DISTANCE, *c*.1828. Canvas, $25\frac{3}{8} \times 57\frac{3}{8}$ (64.5 × 145.5). Acq.no.559.

40. THE CHAIN PIER, BRIGHTON, *c*.1828. Canvas, 28 × 53¾ (71 × 136.5). Acq.no.2064.

41. A SHIP AGROUND, *c*.1828. Canvas, $27\frac{1}{2} \times 53\frac{1}{2}$ (70 × 136). Acq.no.2065.

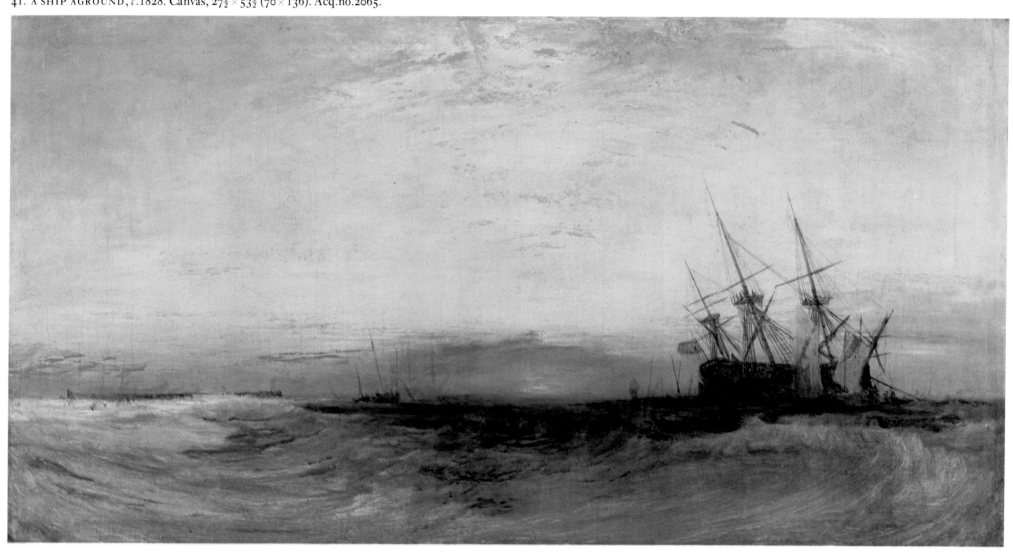

42. SKETCH FOR 'ULYSSES DERIDING POLYPHEMUS', ? 1828. Canvas, $23\frac{5}{8} \times 35\frac{1}{8}$ (60 × 89). Acq.no.2958.

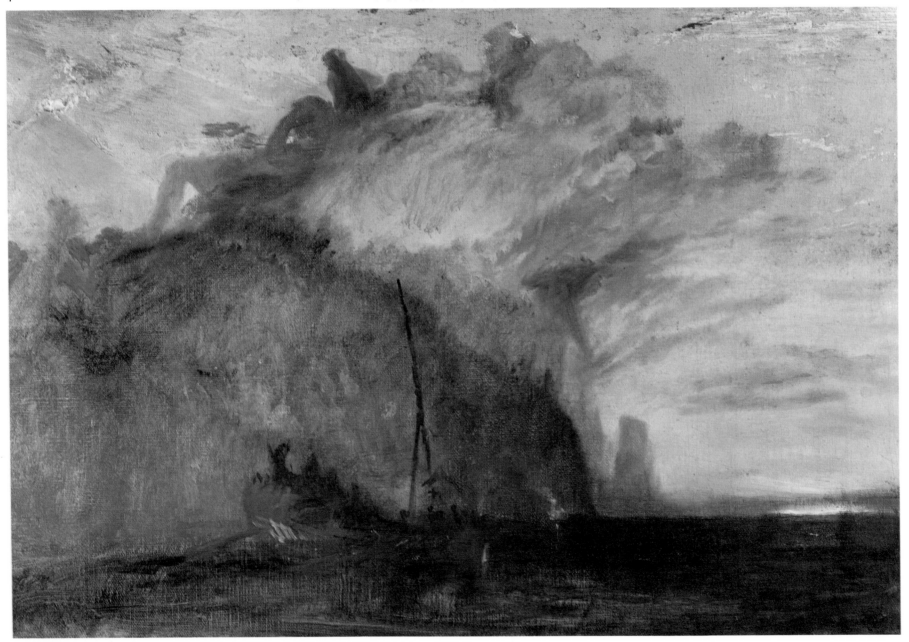

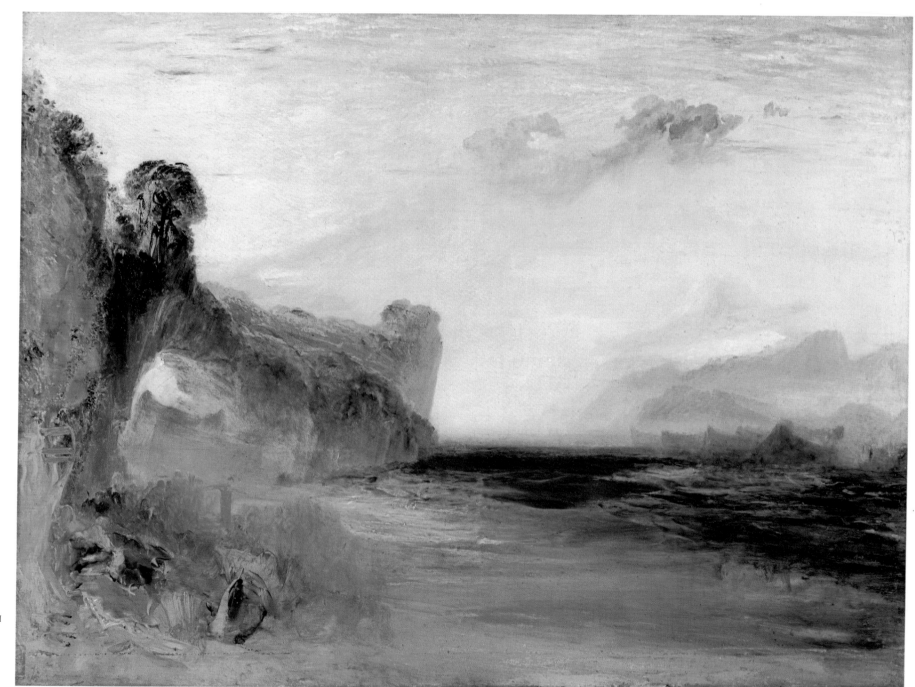

43. ROCKY BAY WITH
FIGURES, *c.*1830.
Canvas, 36×49
(91.5×124.5).
Acq.no.1989.

44. FISHING BOAT IN A MIST, ?1828. Canvas, $23\frac{3}{4} \times 35\frac{3}{4}$ (60×91). Acq.no.3386.

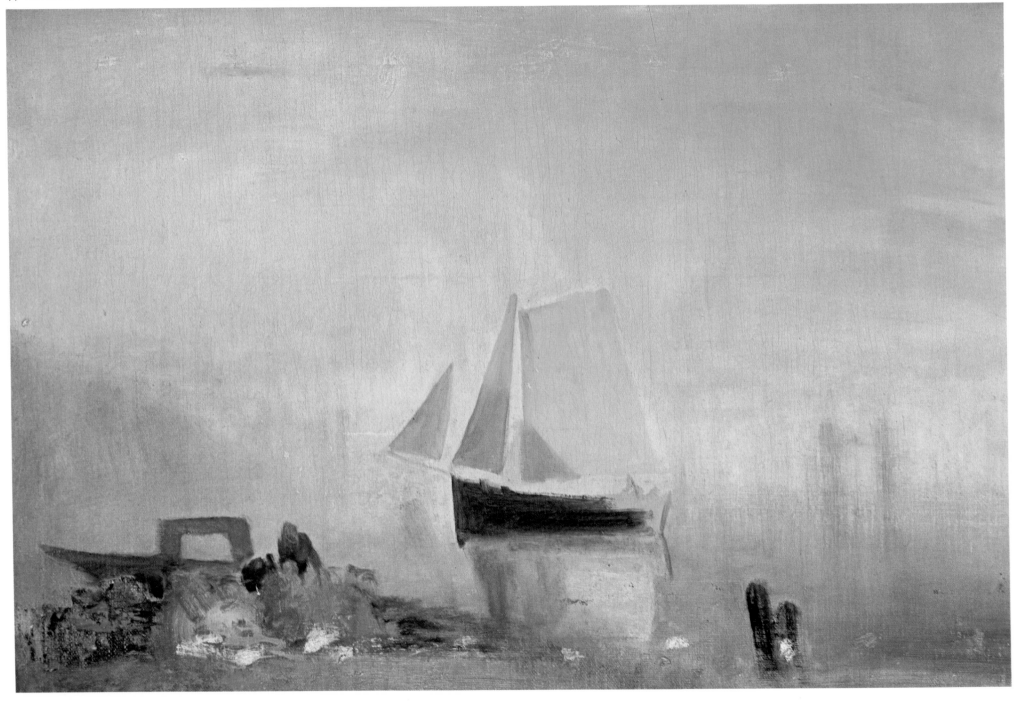

45. LAKE NEMI, ? 1828. Canvas, $23\frac{3}{4} \times 39\frac{1}{4}$ (60.5 × 99). Acq.no.3027.

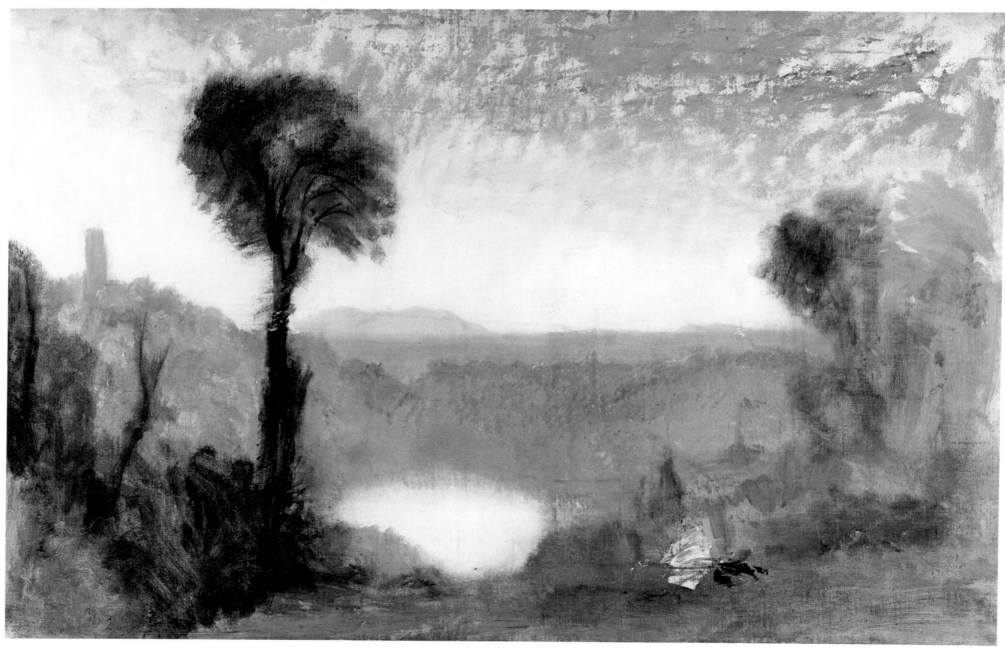

46. COAST SCENE NEAR NAPLES, ? 1828. Millboard, $16\frac{1}{8} \times 23\frac{1}{2}$ (41×59.5). Acq.no.5527.

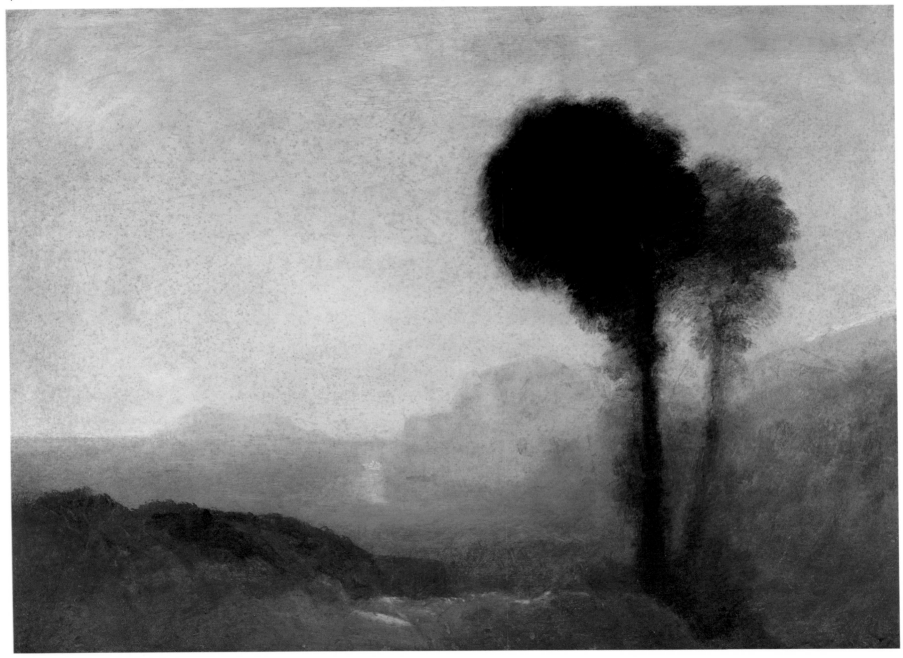

47. ARCHWAY WITH TREES BY THE SEA, ?1828. Canvas, $23\frac{5}{8} \times 34\frac{1}{4}$ (60×87.5). Acq.no.3381.

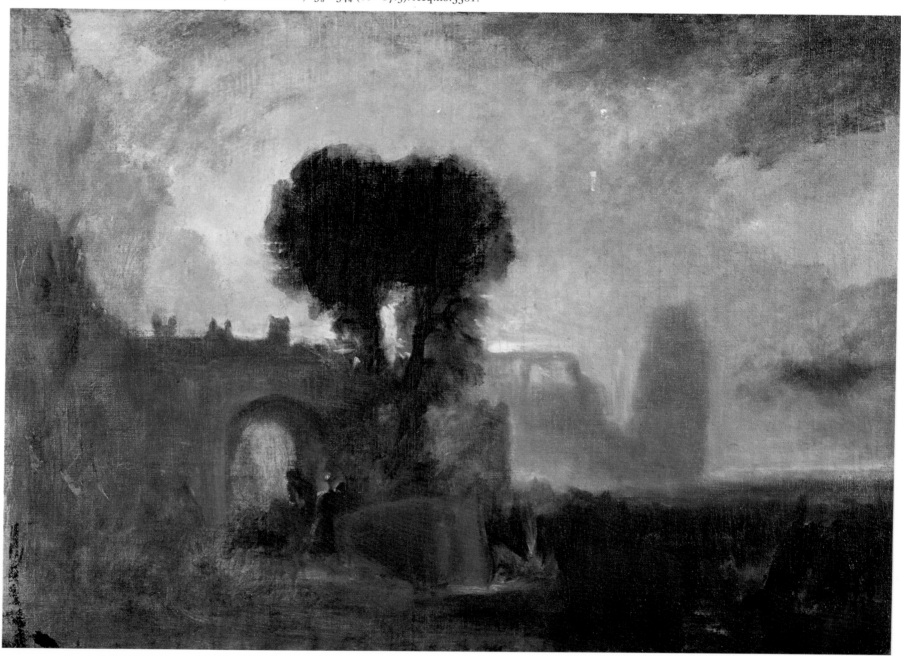

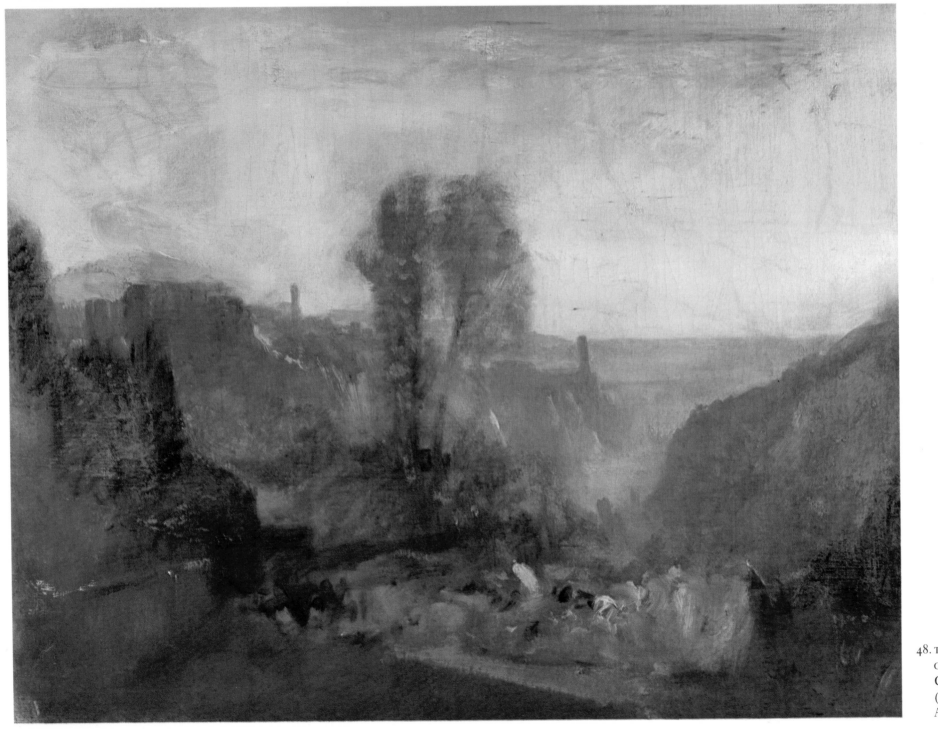

48. TIVOLI, THE
CASCATELLE, ?18
Canvas, $23\frac{7}{8} \times 30\frac{5}{8}$
(60.5 × 78).
Acq.no.3388.

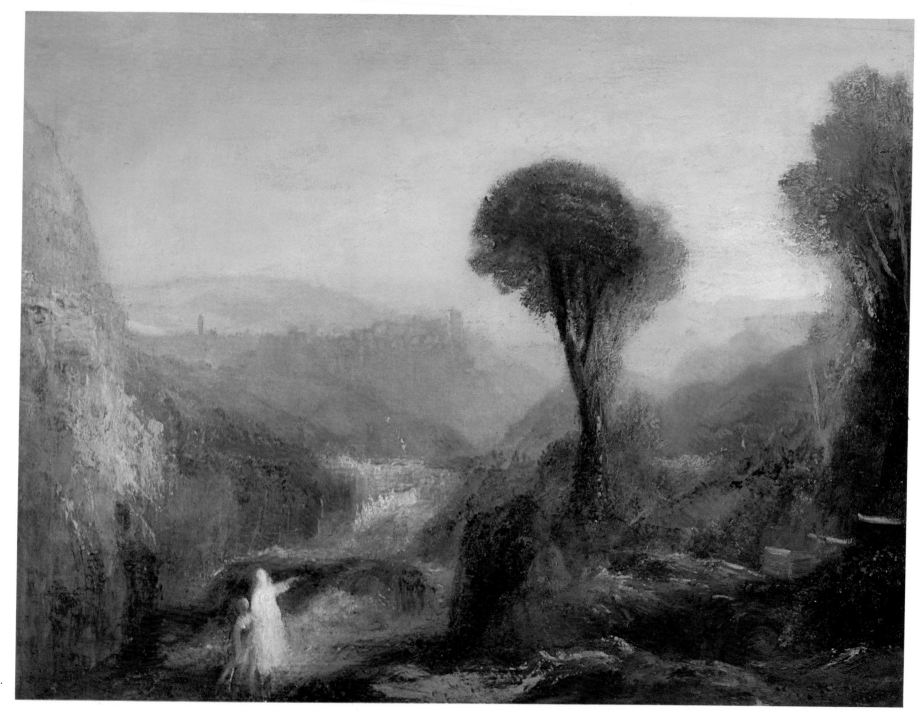

TIVOLI: TOBIAS
AND THE ANGEL,
c.1835. Canvas,
$35\frac{5}{8} \times 47\frac{5}{8}$ (90.5 × 121).
Acq.no.2067.

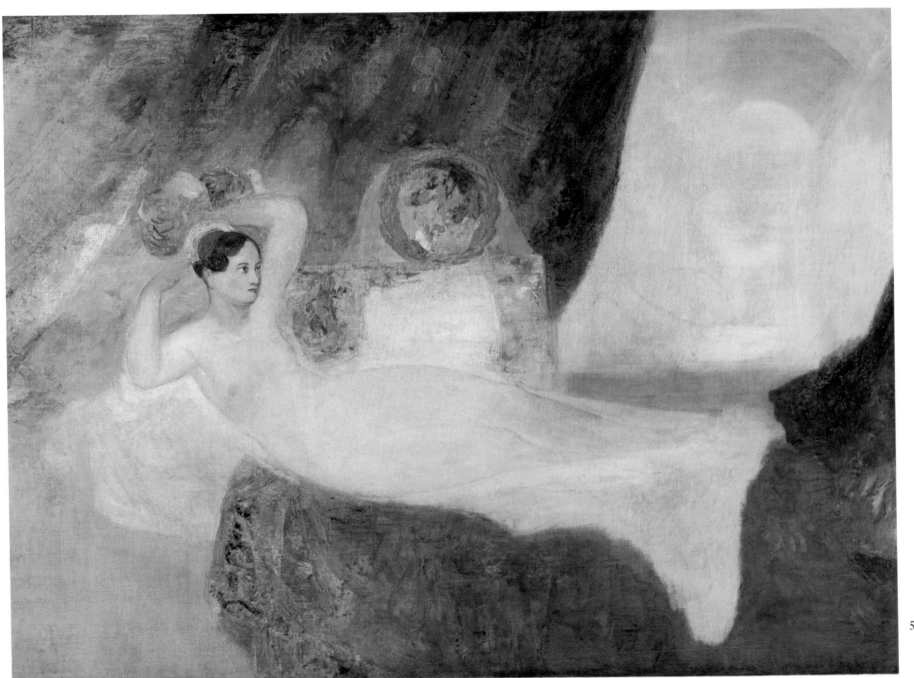

50. RECLINING VENU
1828. Canvas, 69 × 9
(175 × 249).
Acq.no.5498.

51. VISION OF MEDEA, 1828. Canvas, $68\frac{3}{8} \times 98$ (173.5 × 241). Acq.no.513.

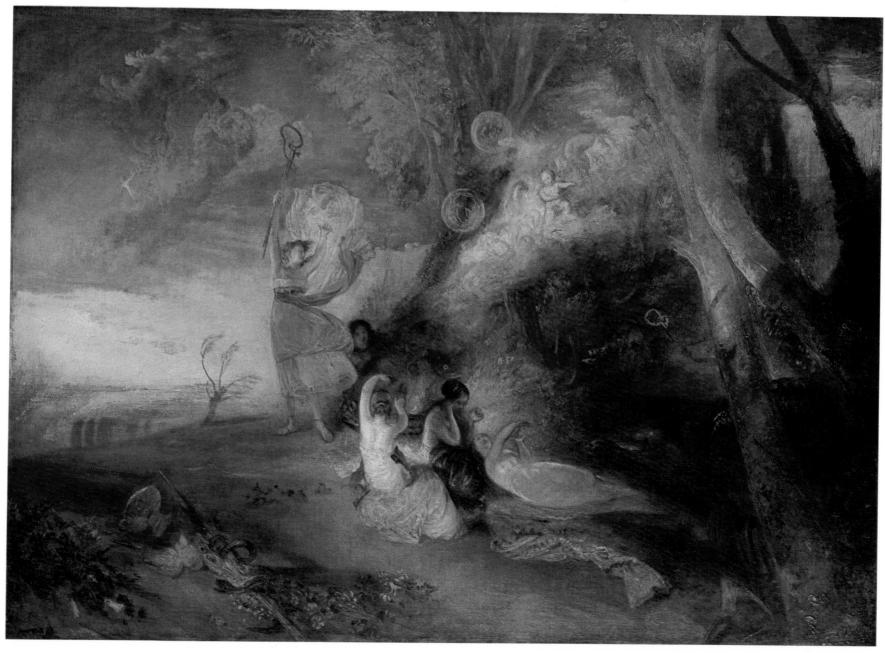

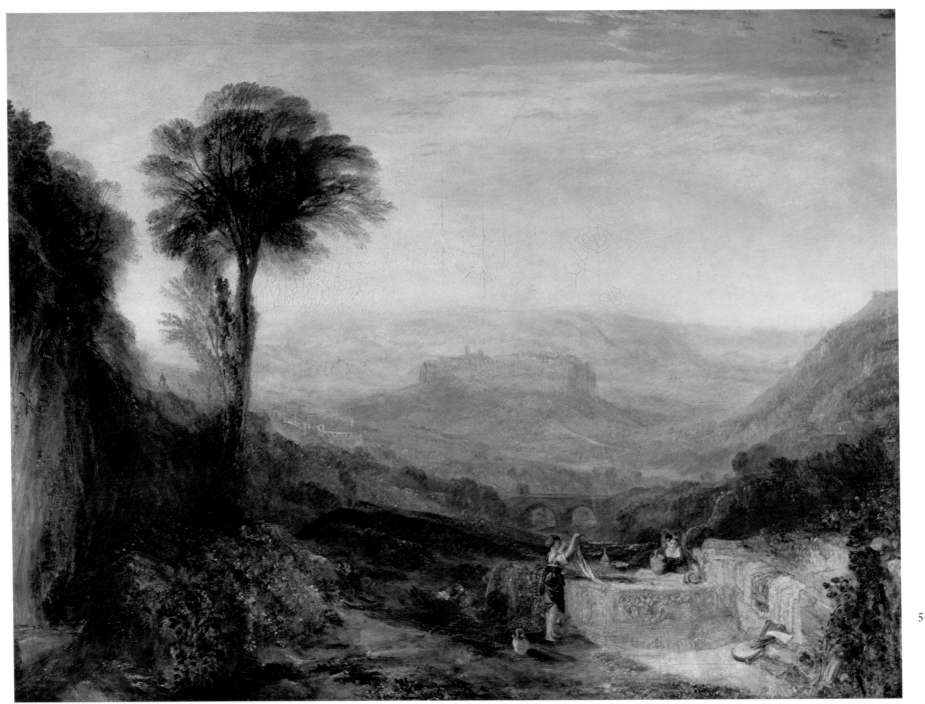

52. VIEW OF ORVIET[O]
PAINTED IN ROM[E]
1828; reworked an[d]
exh.1830. Canvas,
36 × 48½ (91·5 × 12[)]
Acq.no.511.

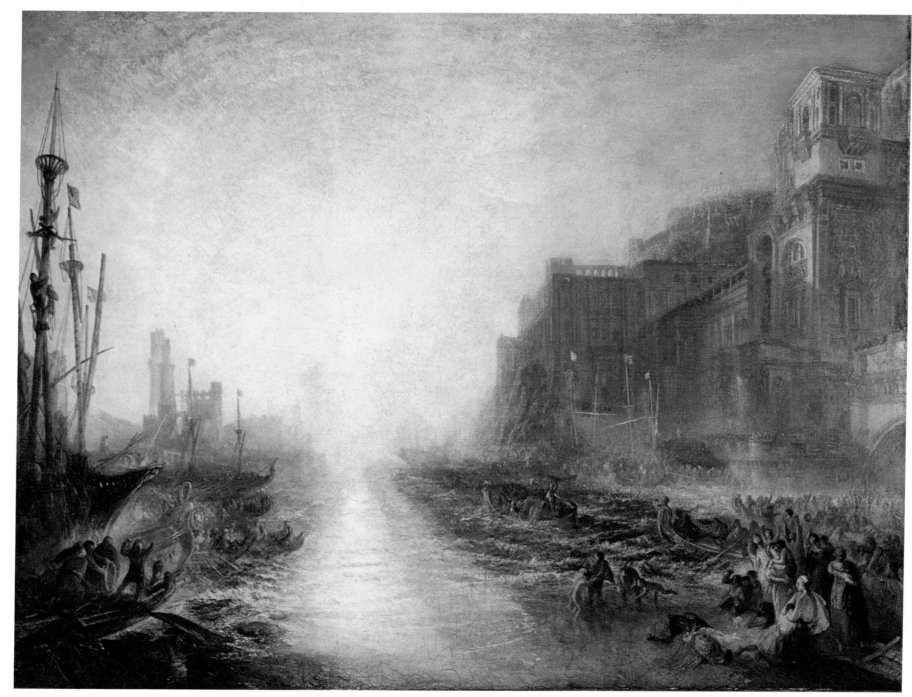

53. REGULUS, 1828;
reworked and exh.
1837. Canvas,
$35\frac{1}{4} \times 48\frac{3}{4}$ (91 × 124).
Acq.no.519.

54. ITALIAN LANDSCAPE, PROBABLY CIVITA DI BAGNOREGIO, ? 1828. Canvas, 59 × 98¼ (150 × 249.5). Acq.no.5473.

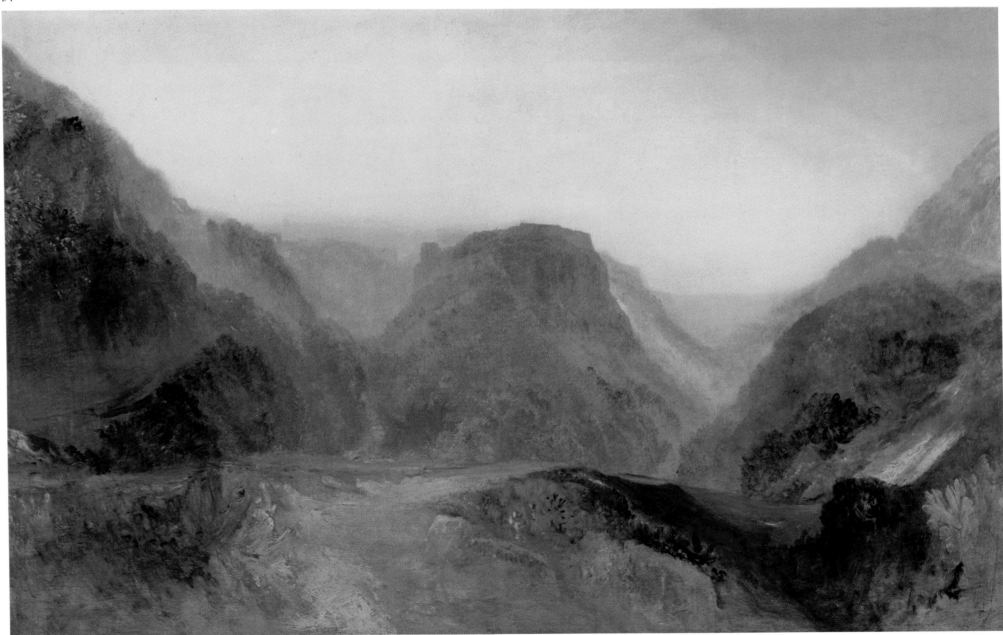

55. CALIGULA'S PALACE AND BRIDGE, exh.1831. Canvas, 54 × 97 (137 × 246.5). Acq.no.512.

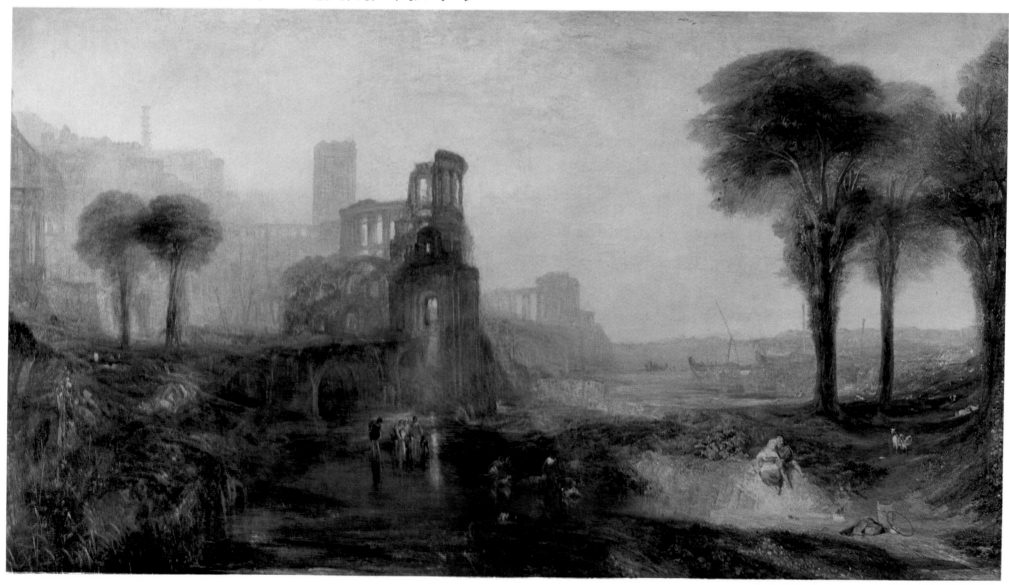

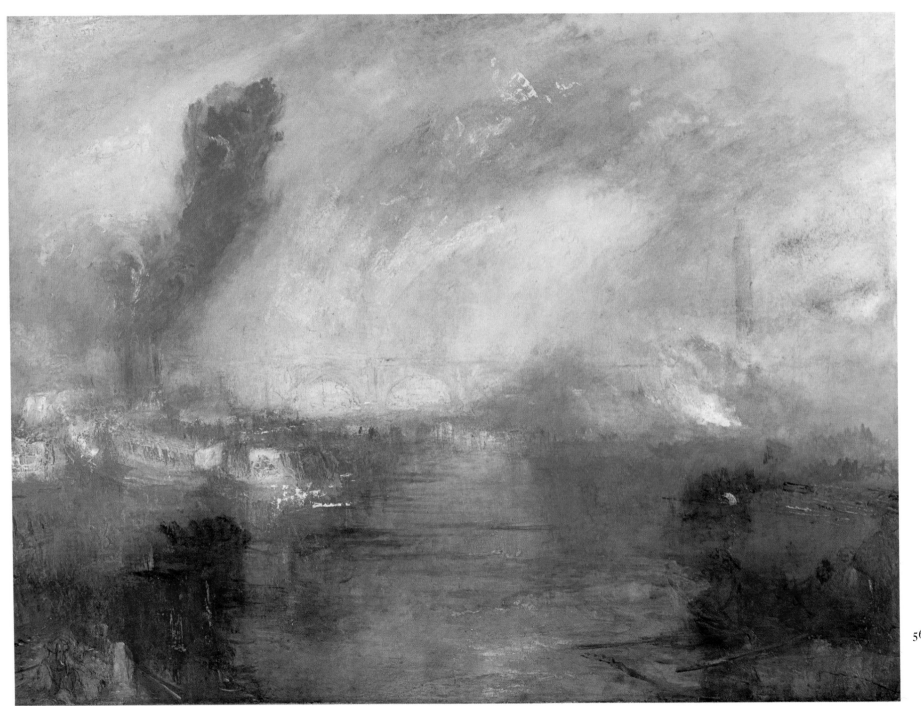

56. THE THAMES ABOV
WATERLOO BRIDG
c.1830–5. Canvas,
$35\frac{5}{8} \times 47\frac{5}{8}$ (90.5 × 12
Acq.no.1992.

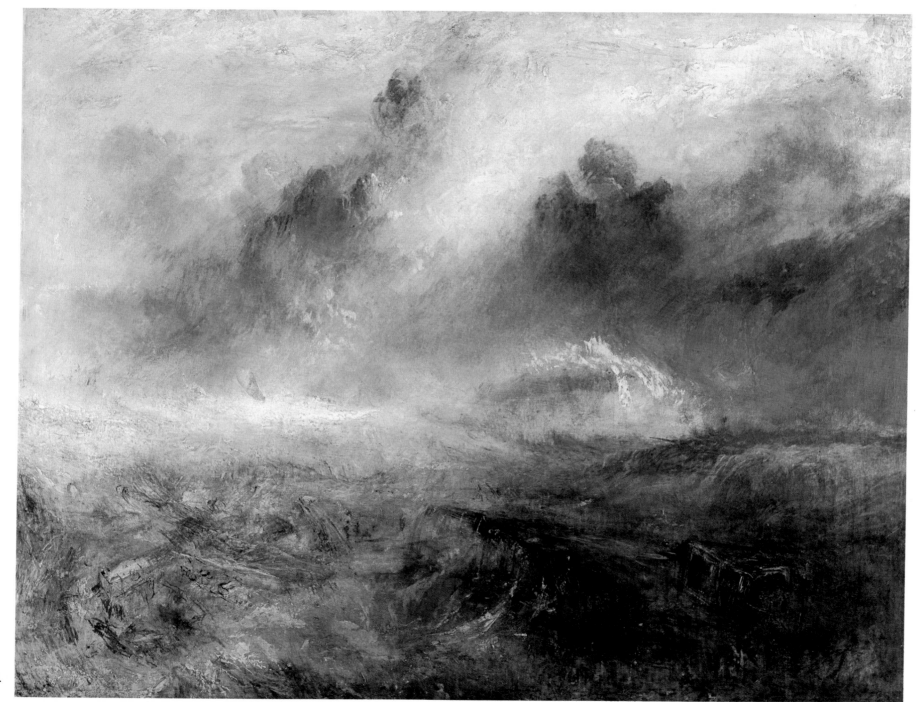

. ROUGH SEA WITH
WRECKAGE,
*c.*1830–5. Canvas,
$36\frac{1}{4} \times 48\frac{1}{4}$ (92 × 122.5).
Acq.no.1980.

58. CHILDE HAROLD'S PILGRIMAGE – ITALY, exh.1823. Canvas, 56×97¾ (142×248). Acq.no.516.

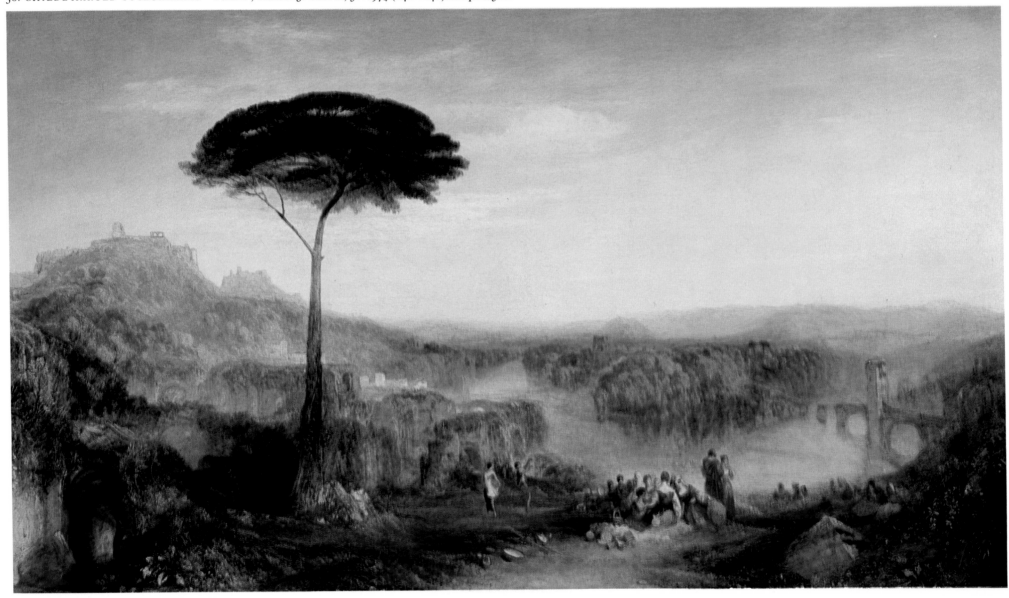

59. STORY OF APOLLO AND DAPHNE, exh.1837. Mahogany, $43\frac{1}{4} \times 78\frac{1}{4}$ (110 × 199). Acq.no.520.

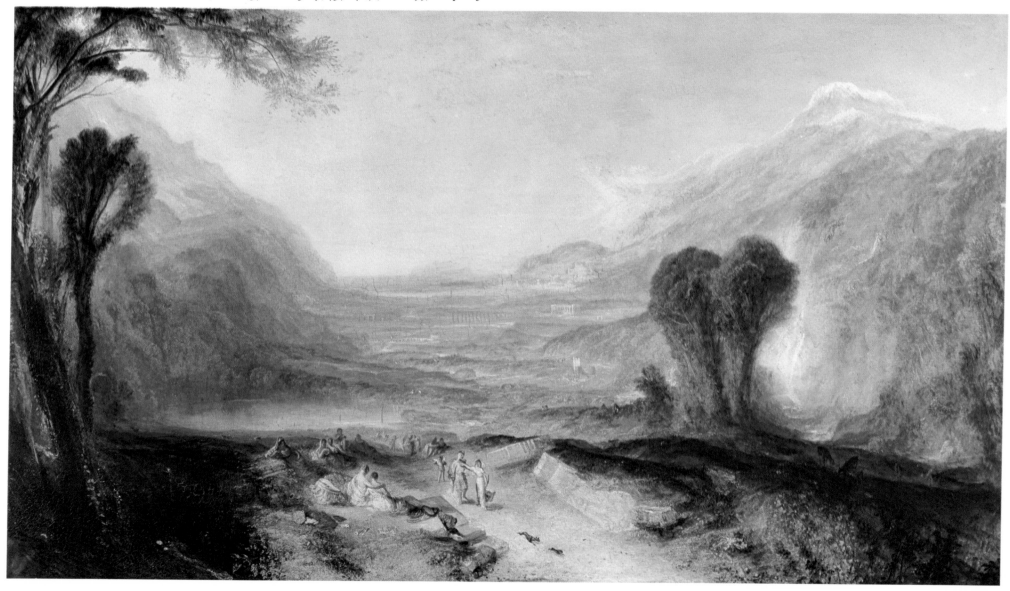

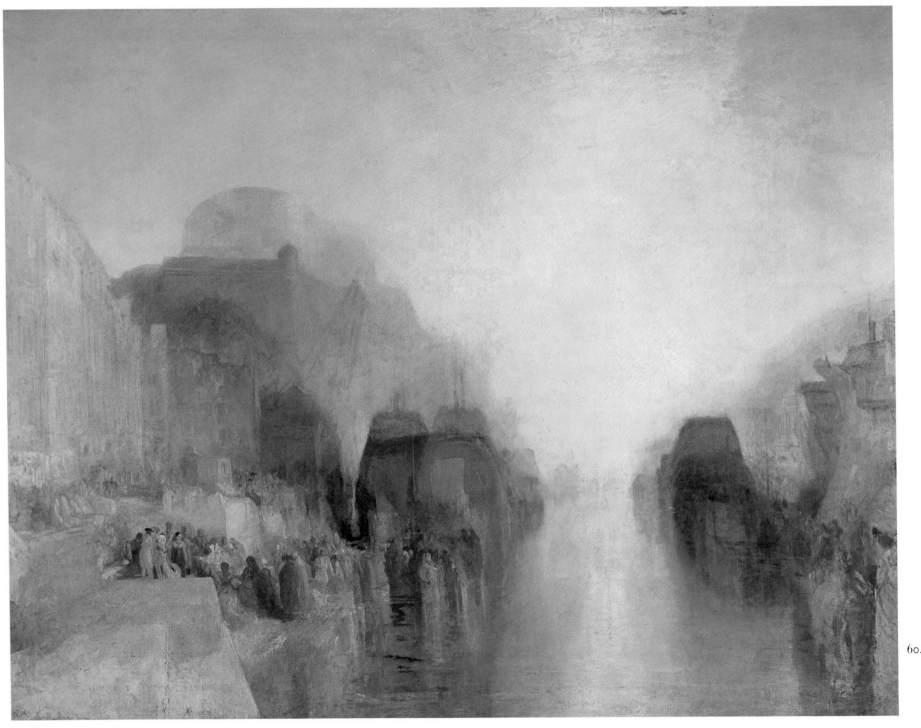

60. HARBOUR WITH
TOWN AND FORTRE[SS]
?c.1830. Canvas,
66×88 (172.5 × 223.5)
Acq.no.5514.

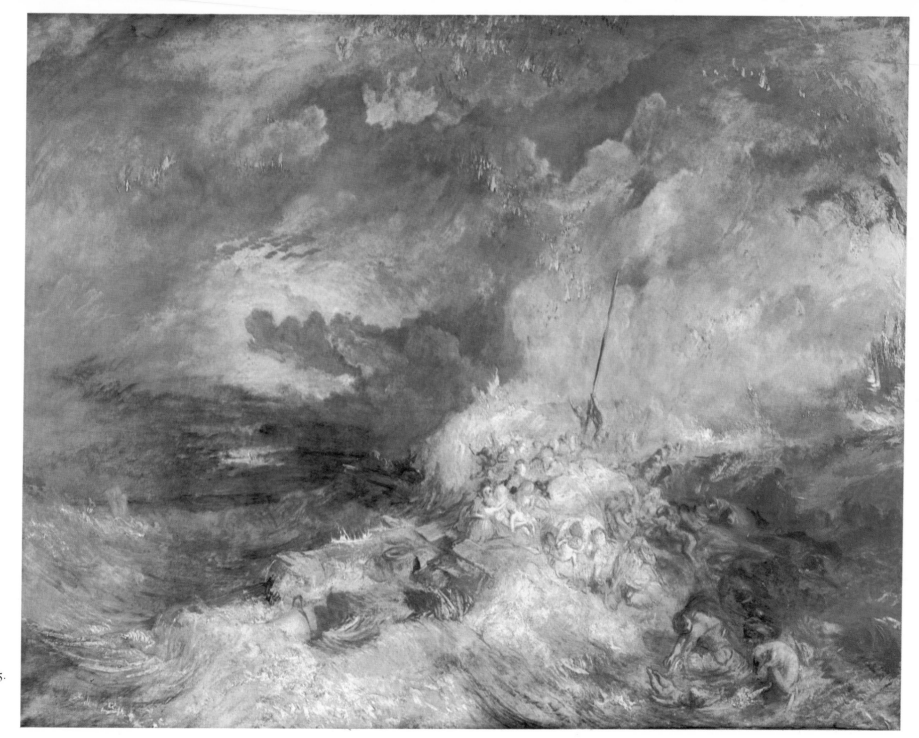

51. FIRE AT SEA, *c*.1835.
Canvas, $67\frac{1}{2} \times 86\frac{3}{4}$
(171.5×220.5).
Acq.no.558.

62. WAVES BREAKING ON A LEE SHORE, *c*.1835. Canvas, 23½ × 37½ (60 × 95). Acq.no.2882.

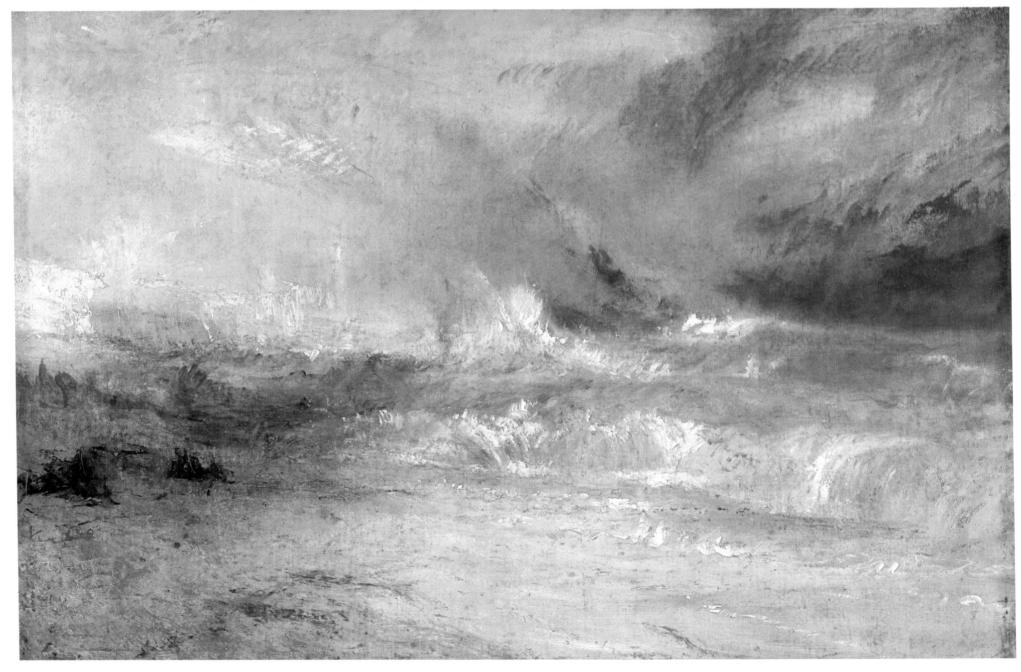

63. BRIDGE OF SIGHS, DUCAL PALACE AND CUSTOM-HOUSE, VENICE: CANALETTI PAINTING, exh.1833. Mahogany, $20\frac{3}{16} \times 32\frac{7}{16}$ (51×82.5). Acq.no.370.

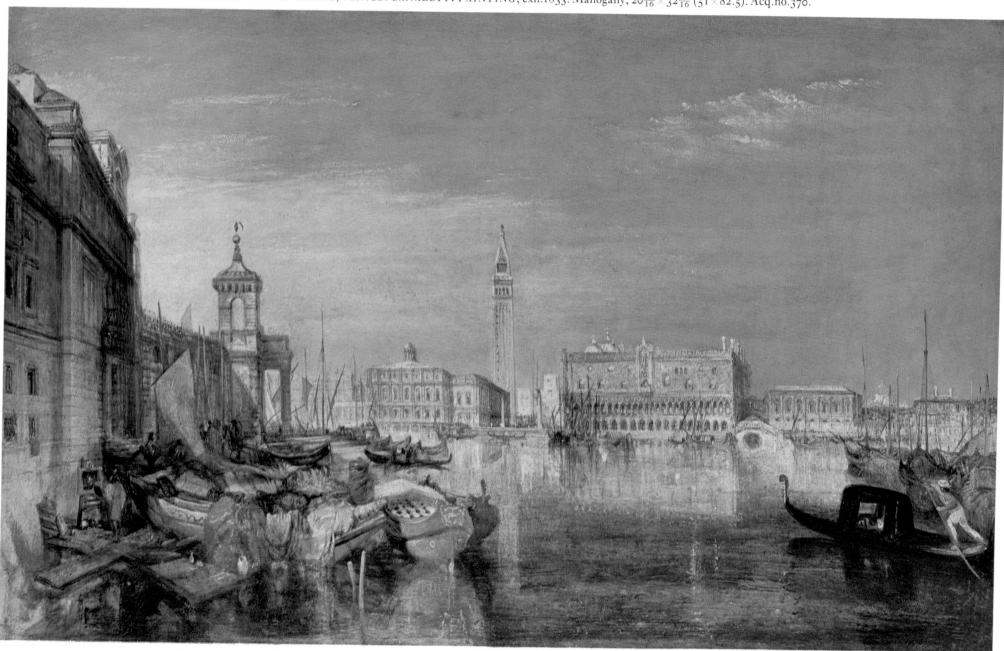

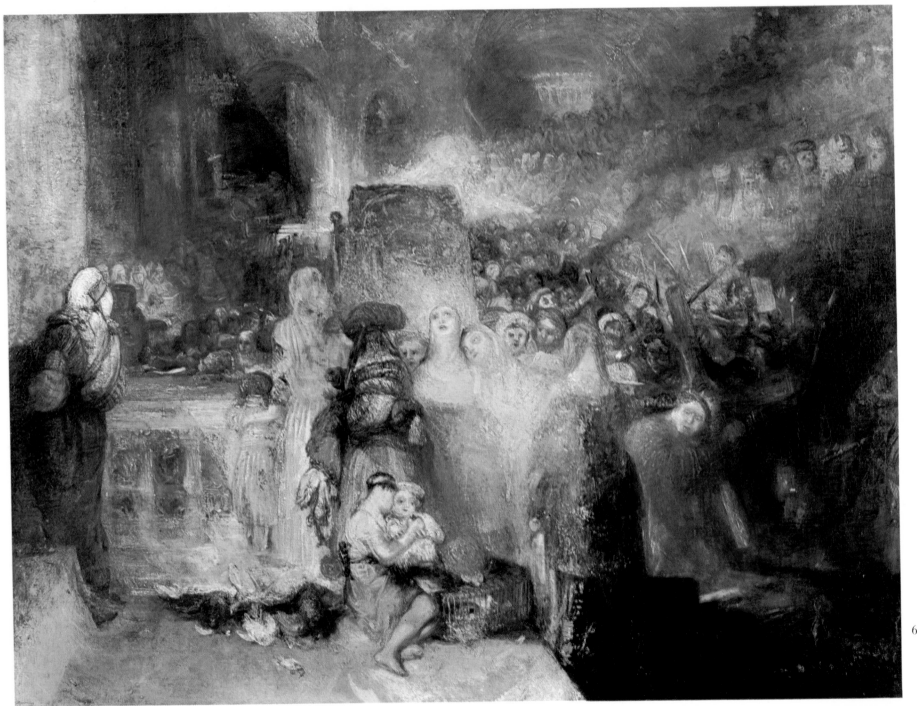

64. PILATE WASHING
HIS HANDS, exh. 1
Canvas, 36×48
(91.5×122).
Acq.no.510.

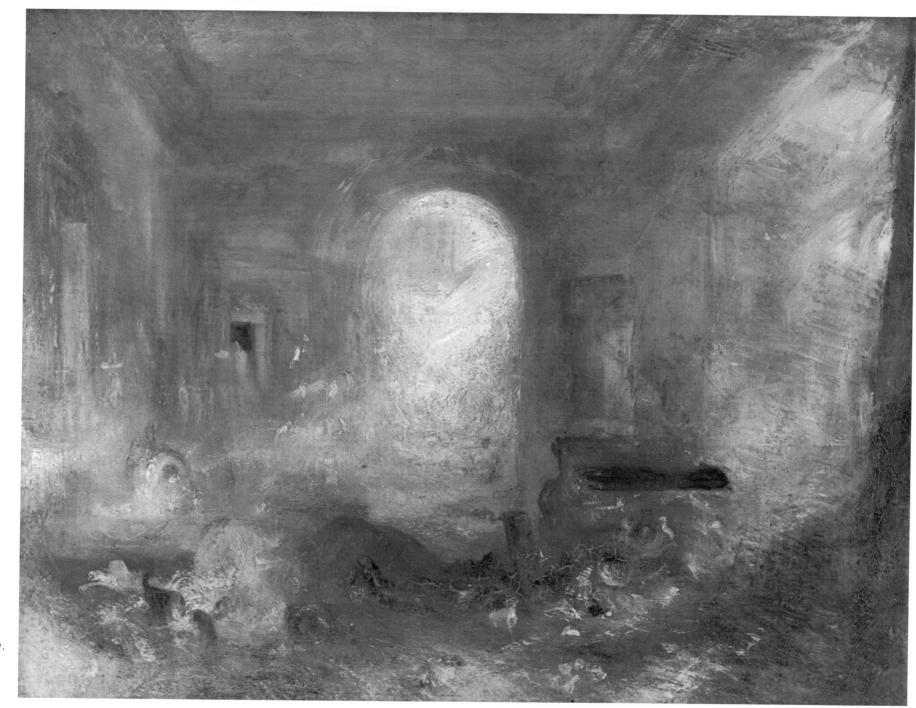

5. INTERIOR AT
PETWORTH, ?1837.
Canvas, 35¾×48
(91×122).
Acq.no.1988.

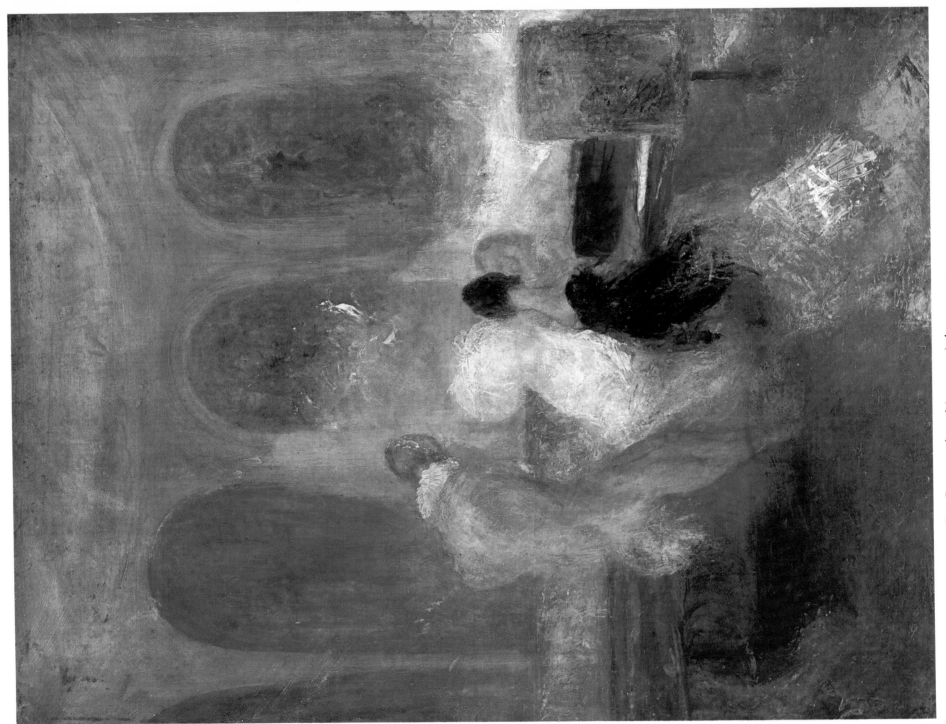

66. MUSIC PARTY, PETWORTH, c.1835. Canvas, 47¾ × 35⅜ (121 × 90.5). Acq.no.3550.

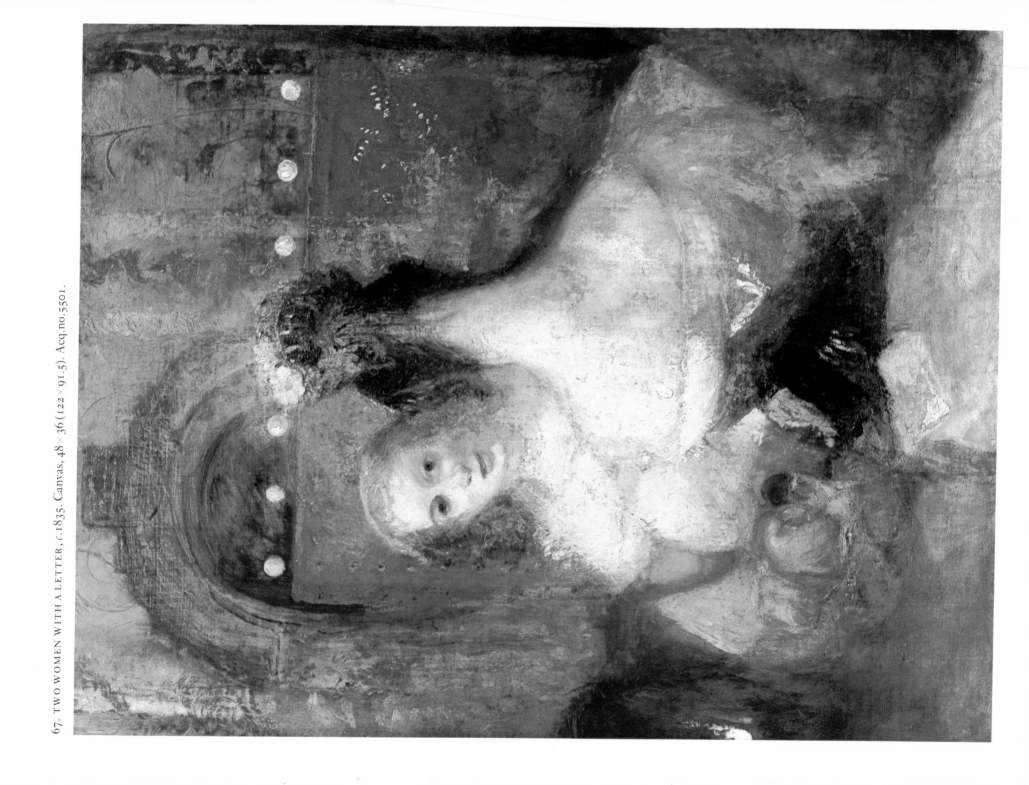

67. TWO WOMEN WITH A LETTER, c.1835. Canvas, 48 × 36 (122 × 91.5). Acq.no.5501.

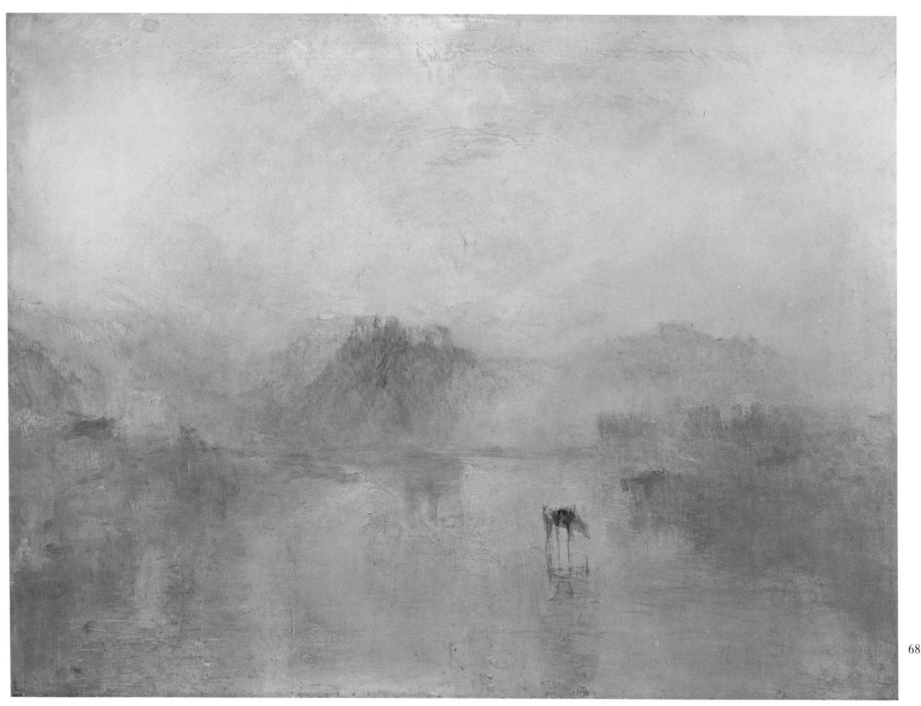

68. NORHAM CASTLE
SUNRISE, *c.*1835–4
Canvas, $35\frac{3}{4}\times48$
(91 × 122). Acq.no.

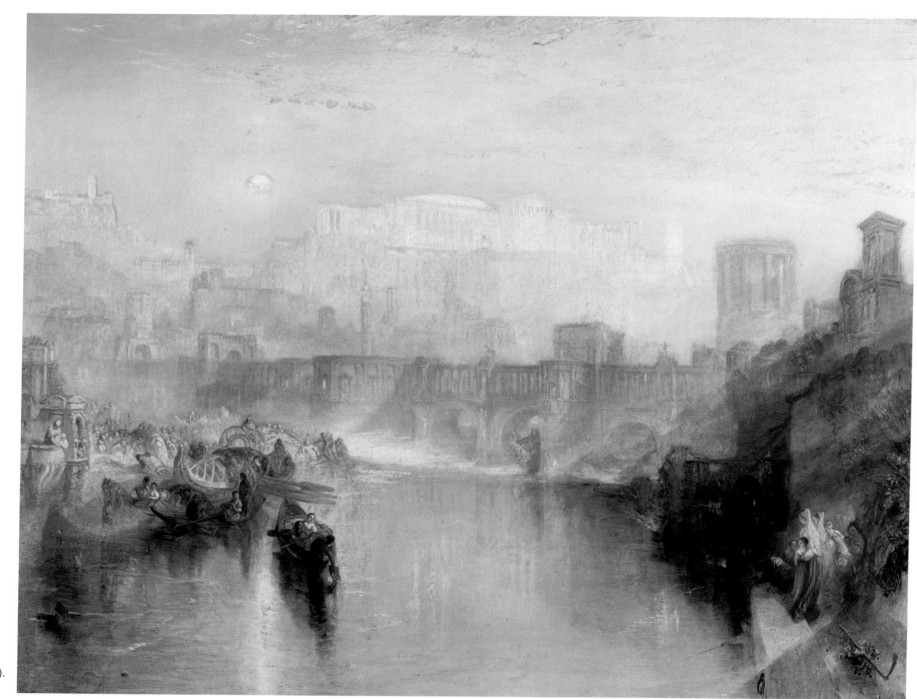

69. ANCIENT ROME;
AGRIPPINA
LANDING WITH
THE ASHES OF
GERMANICUS,
exh.1839. Canvas,
36×48 (91.5×122).
Acq.no.523.

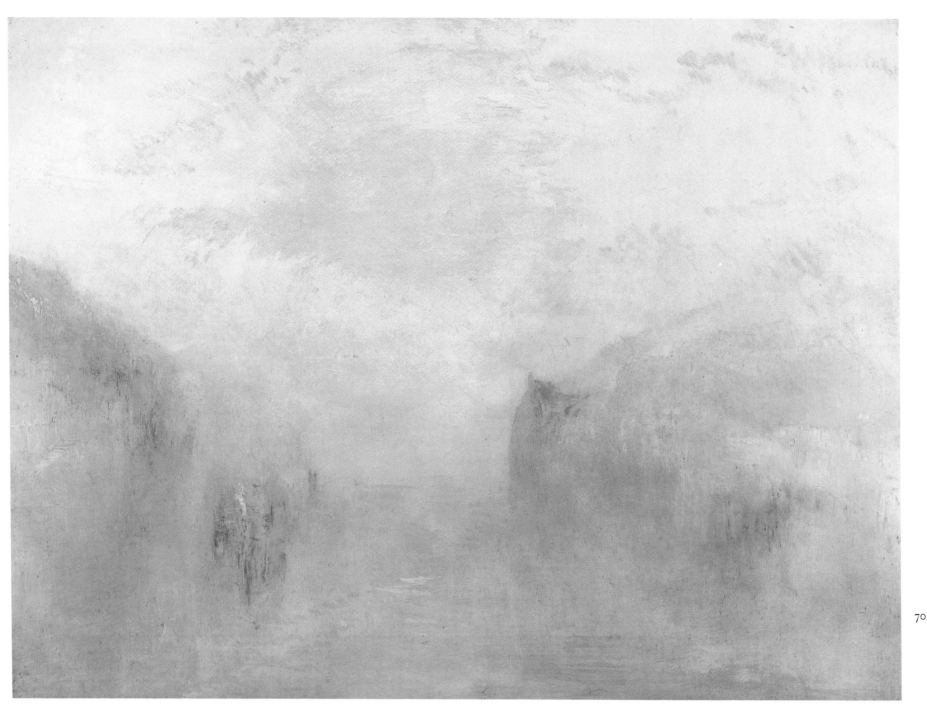

70. SUNRISE, WITH A
BOAT BETWEEN
HEADLANDS,
c.1835–40. Canvas.
36×48 (91.5×122)
Acq.no.2002.

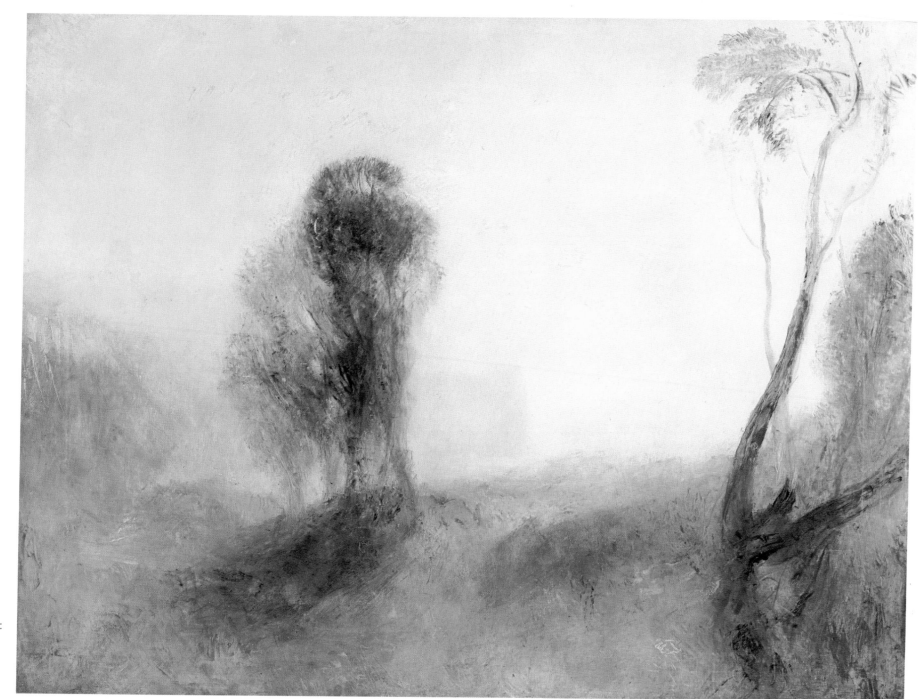

I. SUNRISE, A
CASTLE ON A BAY:
'SOLITUDE',
*c.*1835–40. Canvas,
35¾×48 (91×122).
Acq.no.1985.

72. YACHT APPROACHING THE COAST, c.1835–40. Canvas, $40\frac{1}{4} \times 56$ (102×142). Acq.no.4662.

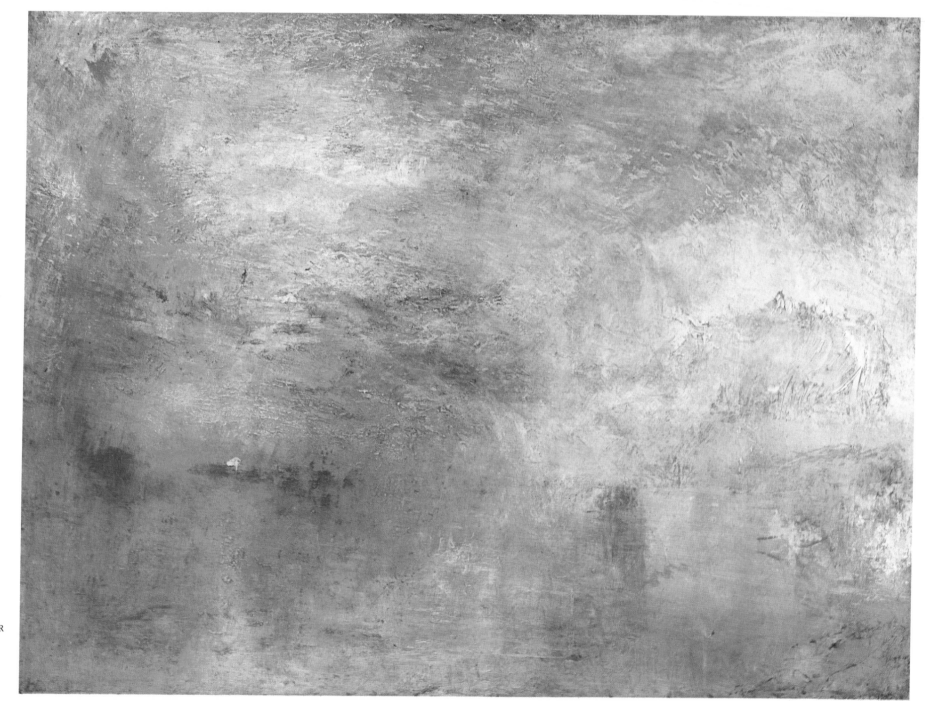

. SUN SETTING OVER
A LAKE, *c.*1840.
Canvas, $35\frac{7}{8} \times 48\frac{1}{4}$
(91 × 122.5).
Acq.no.4665.

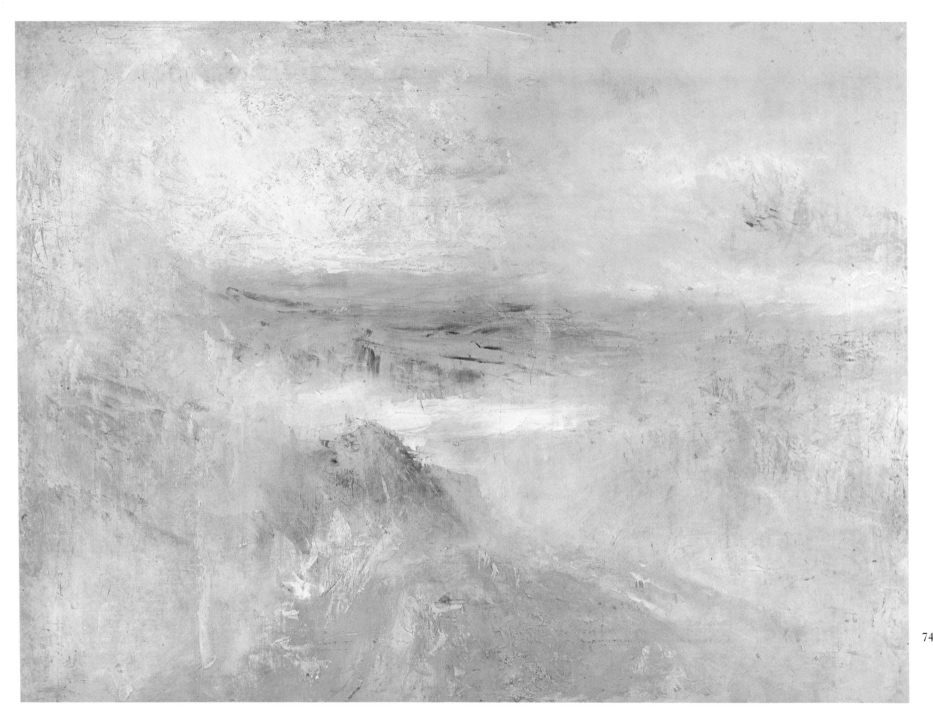

74. MOUNTAIN
LANDSCAPE,
c.1835–40. Canvas
28 × 38 (71 × 96.5).
Acq.no.5486.

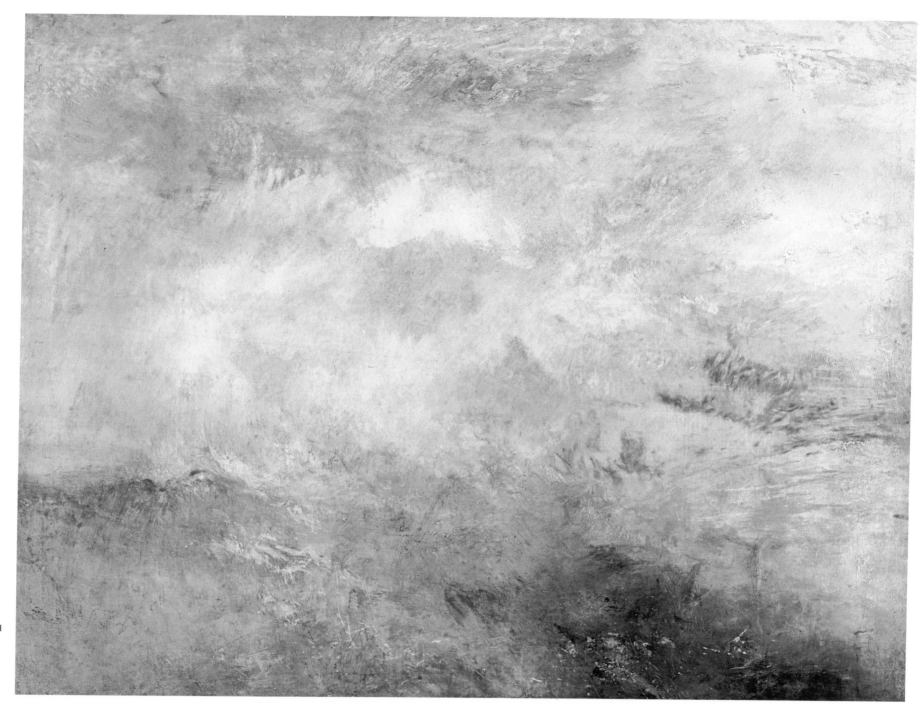

5. STORMY SEA WITH
 DOLPHINS,
 c.1835–40. Canvas,
 $35\frac{3}{4} \times 48$ (91 × 102).
 Acq.no.4664.

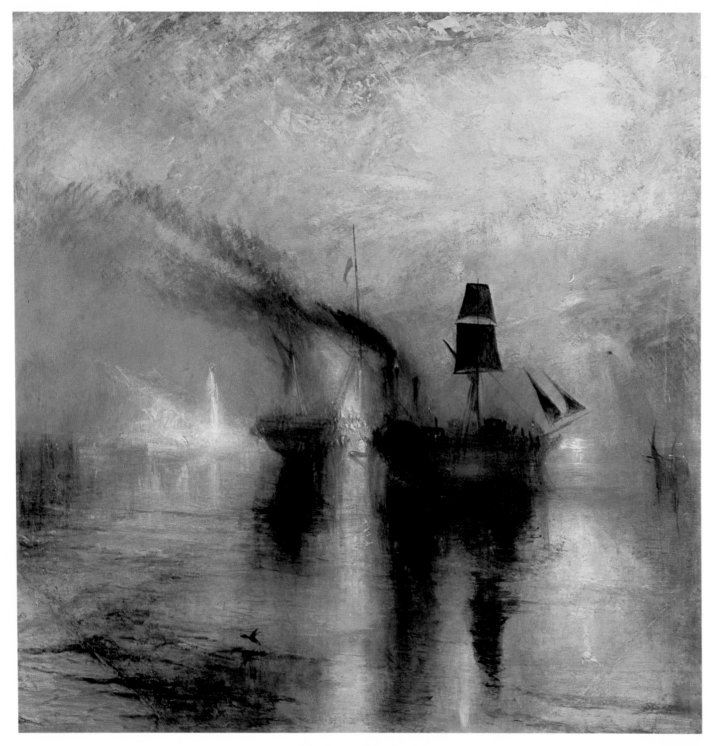

76. PEACE – BURIAL AT SEA, exh. 1842.
Canvas, $34\frac{1}{4} \times 34\frac{1}{8}$ (87×86.5). Acq. no. 528.

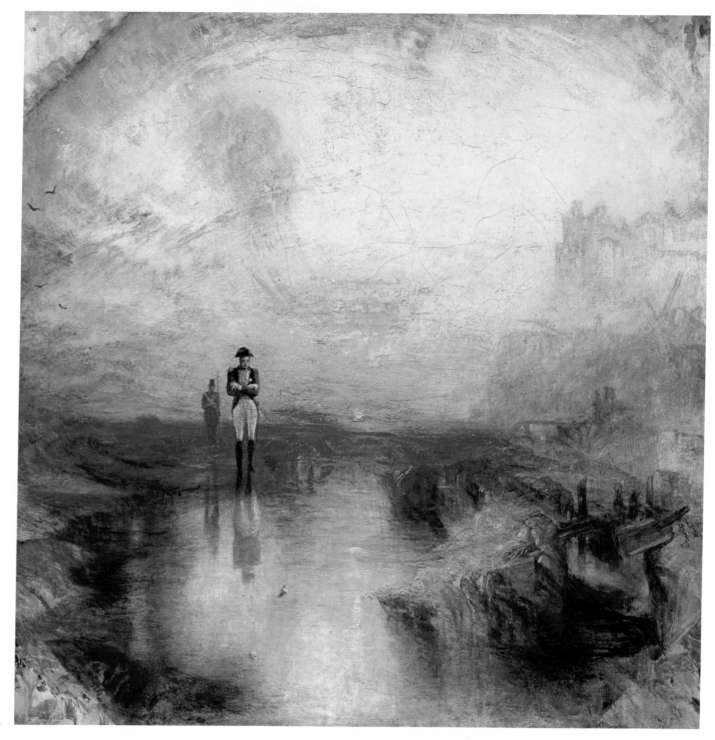

77. WAR. THE EXILE AND THE ROCK LIMPET,
exh.1842. Canvas, $31\frac{1}{4} \times 31\frac{1}{4}$ (79.5 × 79.5). Acq.no.529.

78. THE DOGANA, SAN GIORGIO, CITELLA, FROM THE STEPS OF THE EUROPA, exh.1842. Canvas, $24\frac{1}{4} \times 36\frac{1}{2}$ (62×92.5). Acq.no.372.

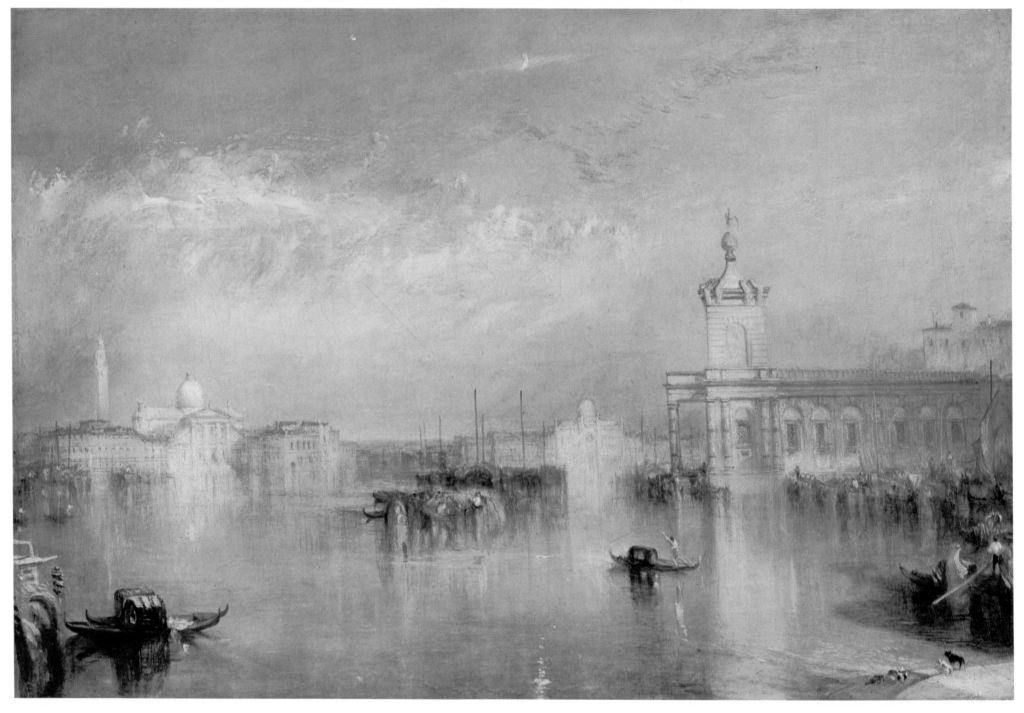

79. ST BENEDETTO, LOOKING TOWARDS FUSINA, exh.1843. Canvas, $24\frac{1}{2} \times 36\frac{1}{2}$ (62.5×92). Acq.no.534.

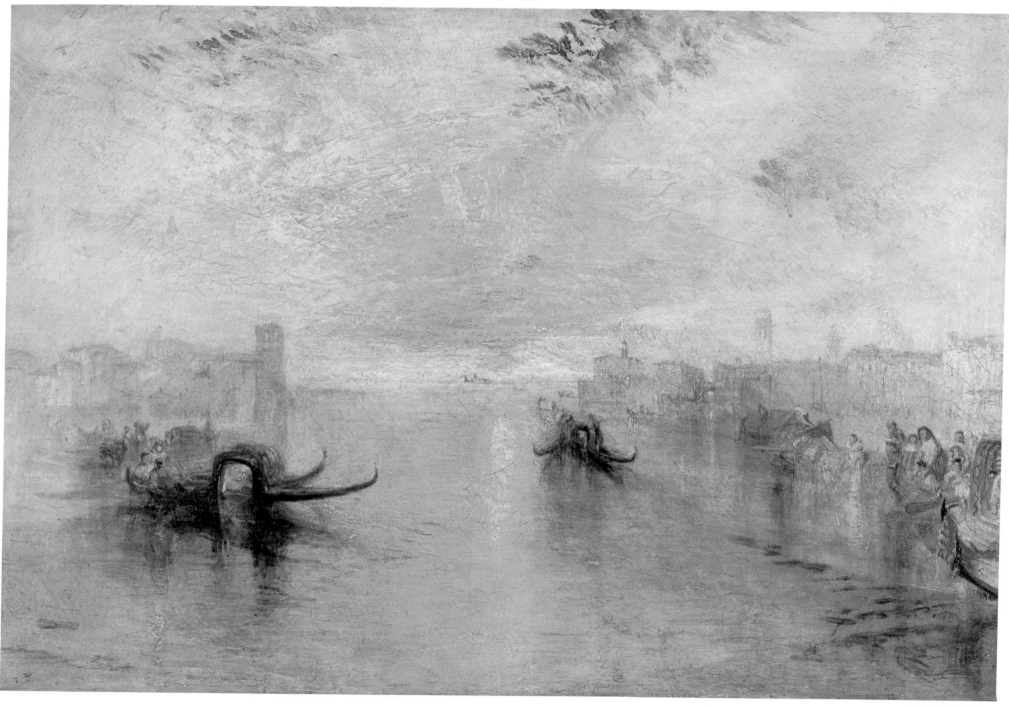

80. VENICE WITH THE SALUTE, *c*.1840–5. Canvas, 24½ × 36½ (62 × 92.5). Acq.no.5487.

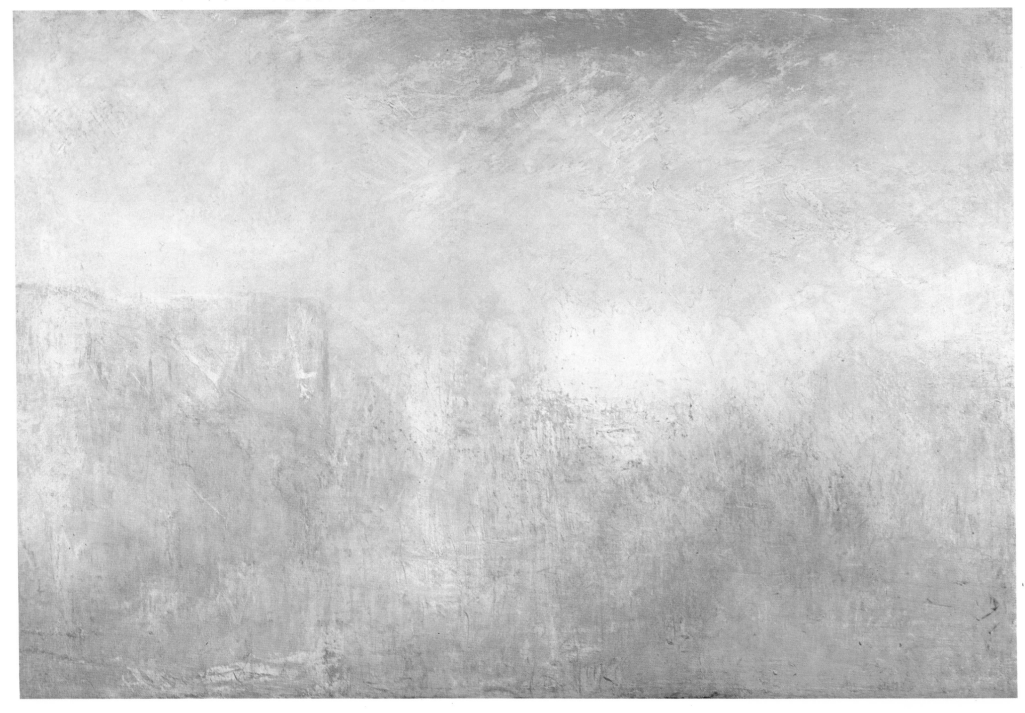

81. THE SUN OF VENICE GOING TO SEA, exh.1843. Canvas, 24¼ × 36¼ (61.5 × 92). Acq.no.535.

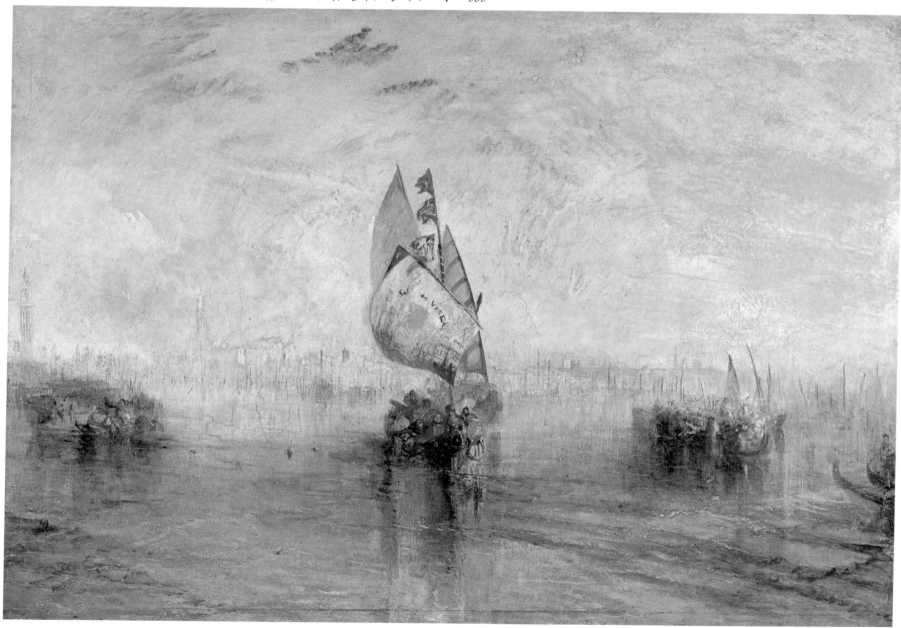

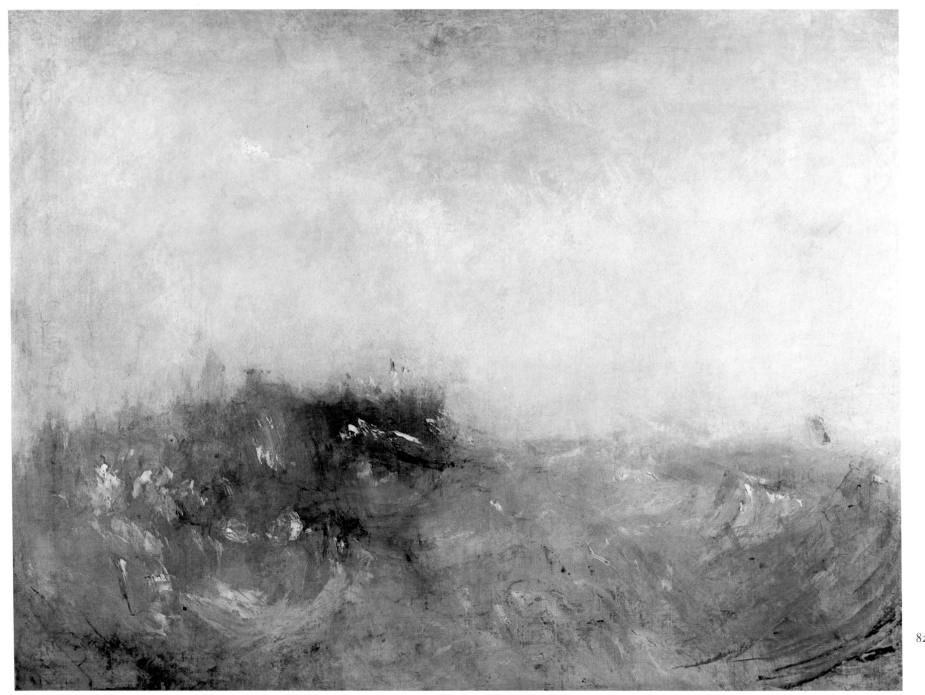

82. ROUGH SEA,
 *c.*1840–5. Canvas,
 36 × 48 (91.5 × 122
 Acq.no.5479.

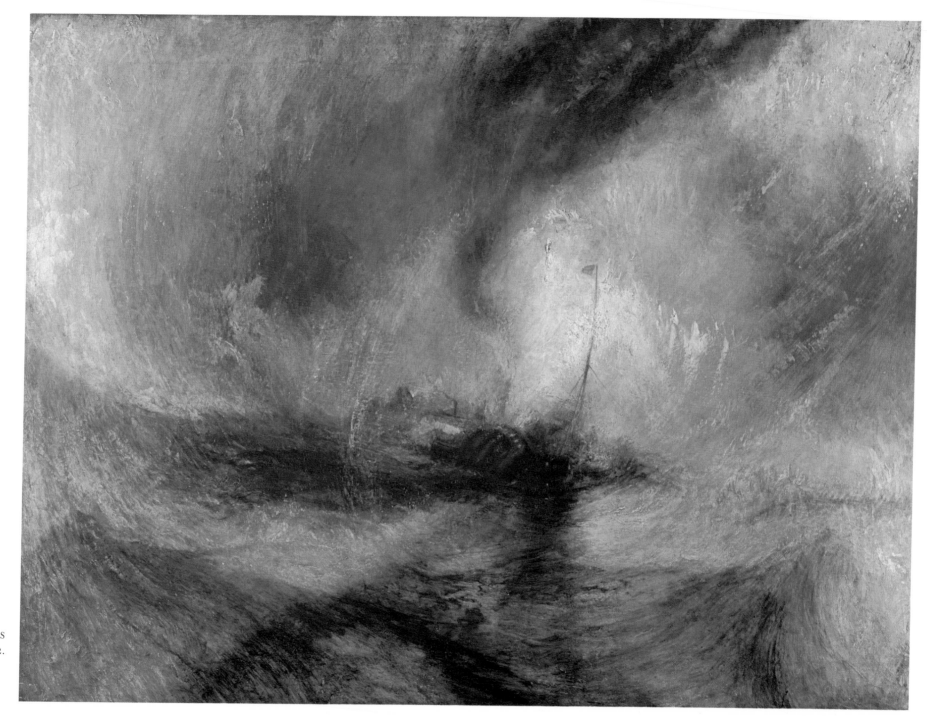

3. SNOW STORM
– STEAM-BOAT
OFF A HARBOUR'S
MOUTH, exh.1842.
Canvas, 36×48
(91.5×122).
Acq.no.530.

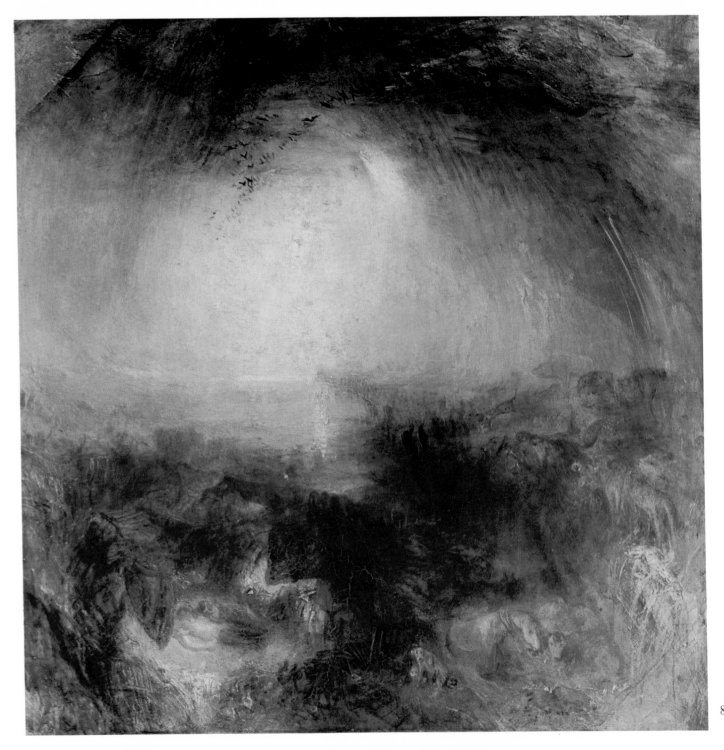

84. SHADE AND DARKNESS – THE EVENING OF THE DELUGE
exh.1843. Canvas, 31 × 30¾ (78.5 × 78). Acq.no.531.

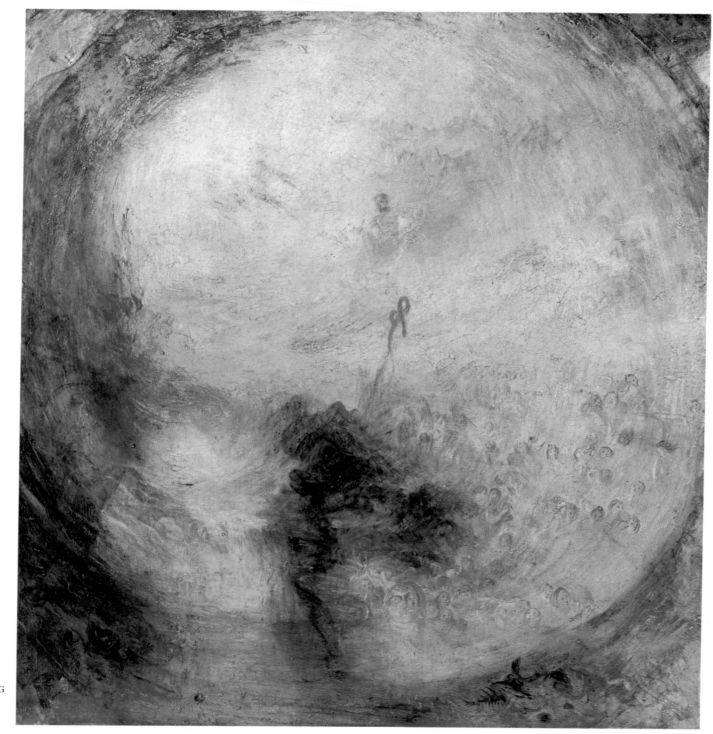

LIGHT AND COLOUR (GOETHE'S THEORY) – THE MORNING
AFTER THE DELUGE – MOSES WRITING THE BOOK OF
GENESIS, exh.1843. Canvas, 31 × 31 (78.5 × 78.5). Acq.no.532.

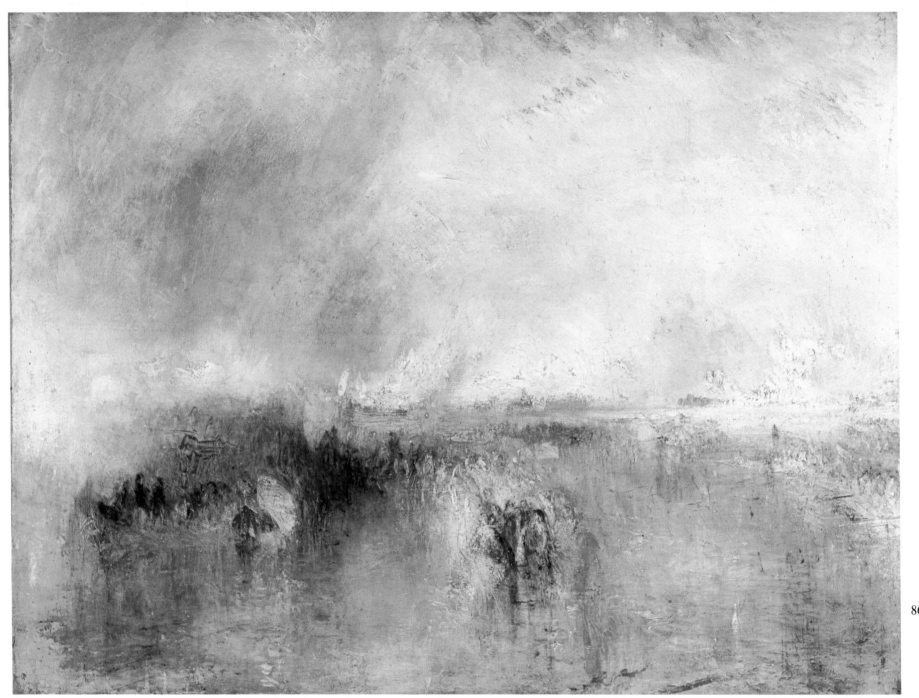

86. PROCESSION OF
BOATS WITH DIST
SMOKE, VENICE,
c.1845. Canvas,
$35\frac{1}{2} \times 47\frac{1}{2}$ (90 × 120.
Acq.no.2068.

87. HEIDELBERG, *c*.1840–5. Canvas, 52 × 79½ (132 × 201). Acq.no.518.

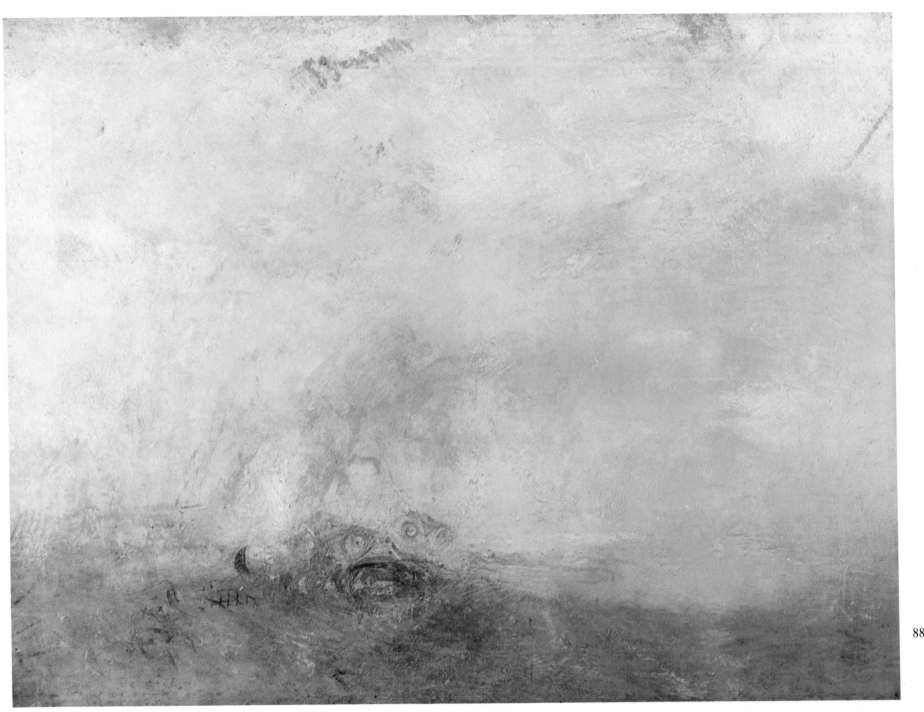

88. SUNRISE WITH SE
MONSTERS, *c*.1845
Canvas, 36×48
(91.5×122).
Acq.no.1990.

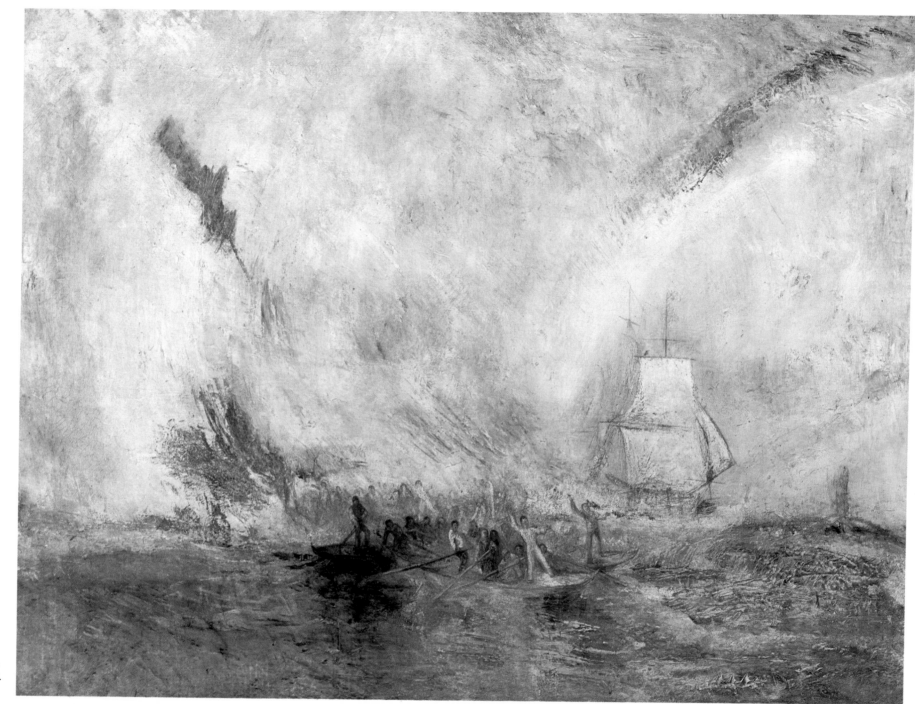

89. WHALERS,
exh.1845. Canvas,
$35\frac{7}{8} \times 48$ (91 × 122).
Acq.no.545.

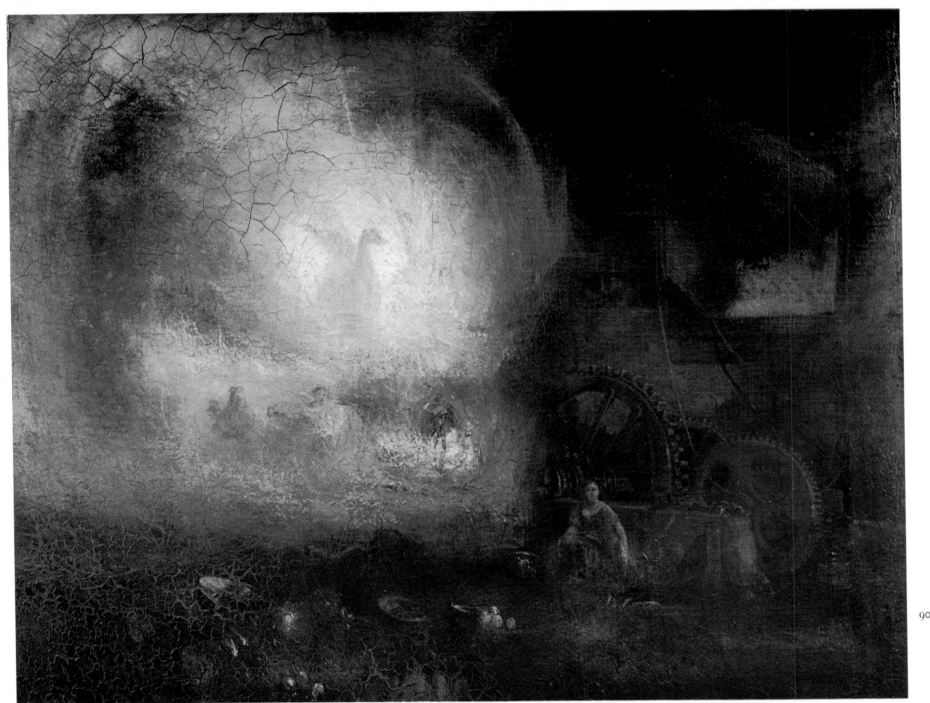

90. THE HERO OF A
 HUNDRED FIGHT
 c.1800–10; rework
 and exh.1847. Can
 $35\frac{3}{4} \times 47\frac{3}{4}$ (91×121
 Acq.no.551.

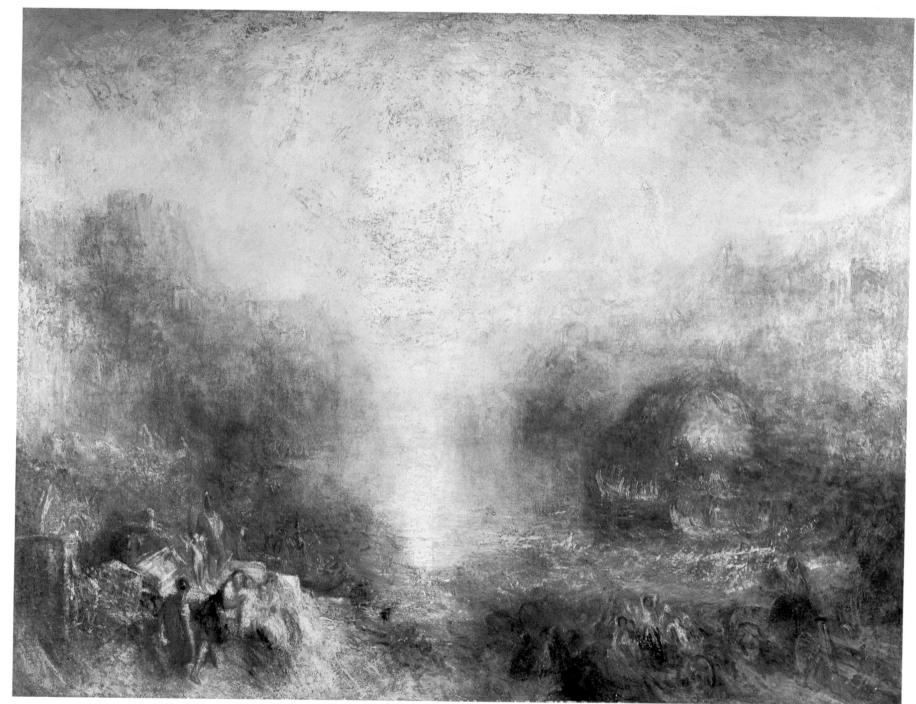

MERCURY SENT TO
ADMONISH AENEAS,
exh.1850. Canvas,
$35\frac{1}{2} \times 47\frac{1}{2}$ (90.5 × 121).
Acq.no.553.

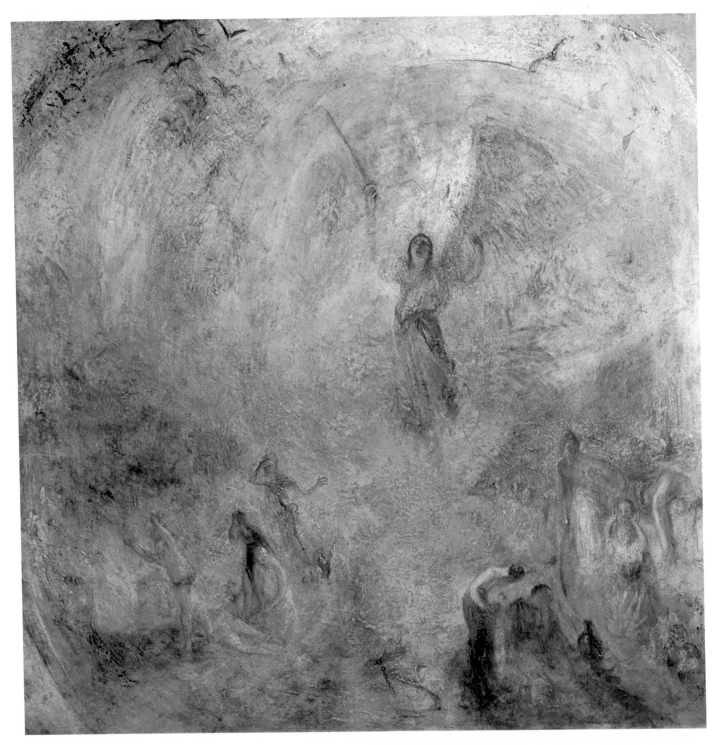

92. THE ANGEL STANDING IN THE SUN,
exh.1846. Canvas, 31 × 31 (78.5 × 78.5). Acq.no.550.